SECRET SEAFORD

Kevin Gordon

AMBERLEY

I would like to dedicate this book to the memory of Pat Berry, who died ten years ago in 2007. She did so much to help me learn about the history of Seaford. I would also like to dedicate this book to the members of Seaford Museum, particularly those who volunteer as stewards and those who work behind the scenes, giving their spare time to such a unique place.

First published 2017

Amberley Publishing
The Hill, Stroud
Gloucestershire, GL5 4EP

www.amberley-books.com

Copyright © Kevin Gordon, 2017

The right of Kevin Gordon to be identified as the
Author of this work has been asserted in accordance
with the Copyrights, Designs and Patents Act 1988.

ISBN 978 1 4456 7212 0 (print)
ISBN 978 1 4456 7213 7 (ebook)

British Library Cataloguing in Publication Data.
A catalogue record for this book is available from the
British Library.

Origination by Amberley Publishing.
Printed in Great Britain.

Contents

Introduction

Secret Seaford! Well, the town itself is a secret. In the thirteenth century it was one of the top forty ports in England and had a bustling harbour. In the eighteenth century it was a centre of smuggling, wrecking and political intrigue. In the late nineteenth and early twentieth centuries it was a school town hosting children from all over the globe, and during the First World War it was the base for two of the largest military camps in the south of England.

Today, however, it is pleasant seaside town usually untroubled by tourists. Surrounded by the South Downs National Park, it is unlikely to expand. There are few empty shops in the town centre and the transport links are good; indeed most Seafordians think that Seaford is just right as it is.

I am sure that most people reading this book live in the town and will think that they know it well. Are there any secrets to be told? Well I hope I have uncovered a few snippets of local history that you will not be aware of.

The book actually takes the form of a long imaginary spiral walk from Cuckmere Haven, across Seaford Head and along the Esplanade to the Sailing Club. Next, inland to Bishopstone and East Blatchington and then into the town centre. If I have not mentioned some of Seaford's secrets that you know about, I will be happy to hear from you.

1. Seaford Head

Cuckmere Haven to Seaford

We start our walk at the river. Now before we begin, you should know that this is not the River Cuckmere! Have a look at any map and you will see that, unlike every other river in the country, this is actually the Cuckmere River. It is one of the few rivers in the country where the word 'river' comes after its name.

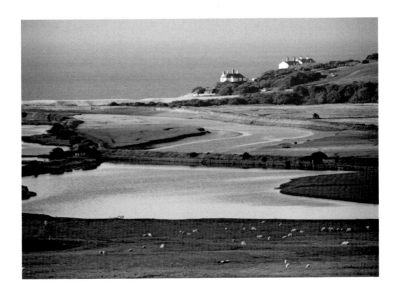

Cuckmere Haven.

When Delhi Protected Burma

This is one of the only rivers on the south coast which flows into the sea in a rural location. Most other rivers have a town or port and are protected with forts. Not so the Cuckmere River, there is no town here and there are no apparent defences. This remote area was an obvious entry point for contraband and there is plenty of evidence of smugglers using the bay, particularly those of the Alfriston Gang led by the infamous Stanton Collins. On 9 September 1783, it is reported that between 200 and 300 smugglers arrived here on horseback to help land goods from ships. During the Napoleonic Wars the area was protected with two barracks on either side of the mouth of the river but these were demolished after Wellington's victory at Waterloo.

This lack of defence was not forgotten during the Second World War. Evidence can be seen nearby in the form of pillboxes and 'dragon's teeth' – circular concrete tank-traps to thwart an enemy landing. We will see more of these on our walk.

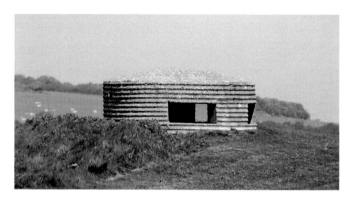

A pillbox on Seaford Head.

Another wartime defence was top secret. In September 1942, the Air Ministry surveyed this area with a view to creating a 'QL' site here. A QL site was an area of decoy lighting, designed to fool enemy pilots into thinking it was another place – in this case the strategic port of Newhaven. The plan was that prior to an air raid, the lights of Newhaven would be extinguished and those here would be turned on to simulate the docks and street lights. This plan would be supplemented by 'QF' sites – small fires lit to represent bombed buildings.

During the war the secret military name for the Cuckmere River was 'Delhi' and Newhaven was 'Burma'.

It appears that, like many wartime plans, there was a lack of communication between different departments. While the Air Ministry was making arrangements for the decoy site to attract enemy aircraft, an undersea cable was being laid nearby by the General Post Office to connect England with France. The code for the four-wire connection was QQMI XJH and the Control Room was just to the west of Exceat Bridge, manned by GPO staff and protected by armed sentries. Should the decoy site at Cuckmere Haven be activated it would have put not only the men based here at risk, but also the vital cross-Channel cables. It is not surprising that the decoy was abandoned less than a year after it was built.

I am surprised that the idea of a decoy site at Cuckmere Haven was even considered. The iconic and very visible white chalk cliffs of the Seven Sisters would have been easily recognised even on the darkest nights to assist the Luftwaffe with directions!

A Memorial That Is Not What It Appears

In the field opposite the Coastguard Cottages at Cuckmere Haven is a stumpy flint cairn apparently commemorating a harrowing incident during the Second World War, but all is not as it seems.

For many years a local resident left poppies nearby. He would tell an extraordinary tale which is recorded on the monument:

I will never forget the day in 1940 when a Canadian company came to Cuckmere and pitched their tents in this field. I was stationed here and knew the bombers regularly used the valley for navigation purposes. I tried to tell the commanding officer but he was not interested in what I had to say. Two mornings later the Messerschmitts arrived. Just as the sun was rising they came skimming over the water and up the valley. Around

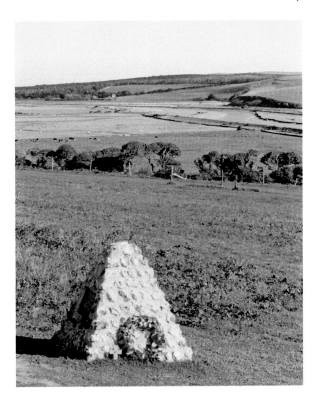

The controversial war memorial.

Alfriston they banked hard and came back. Bearing down on the tents they opened fire. Steam, soil and grass rose in front of them as bullets and bombs entered the ground. All the young men in the marquees and bell tents were killed. The Commanding Officer, who was shaving at the time in the middle coastguard cottage, died instantly when a shell went through the wall that held his mirror.

The monument was unveiled by the Mayor of Seaford in 2006 but there is a problem: there is no record of the incident ever taking place.

Peter Longstaff-Tyrell of the Sussex Military History Society has done his best to ascertain details of this raid. I assisted him a few years ago checking records at the National Army Museum and Imperial War Museum, with the result being that there is no record of any such incident in regimental diaries or coroner's records and there are no local graves.

I was told on more than one occasion that the matter was still 'secret', but this is highly unlikely for an incident that happened nearly eighty years ago. Peter managed to find only one incident that may relate: on 9 July 1942, two Messerschmitt 109 Luftwaffe planes dropped two 500-lb bombs on nearby Friston Airfield. They then strafed Cuckmere Haven with cannon and machine-gun fire. Three Canadian servicemen were killed: Private Jimmy Mahoney of the Army Medical Corps, Sapper Reginald McNally, and Lieutenant Robert Craufurd of 18 Field Company of the Royal Canadian Engineers. They are buried at Brookwood cemetery. Why they were not buried at nearby Seaford cemetery where scores of their colleagues from the First World War are interred remains a mystery.

DID YOU KNOW?
A Canadian war grave at Seaford cemetery commemorates Edward Hornblower, who died of illness while training in Seaford during the Great War. Before emigrating to Canada, he attended Allyns School in South London and his name appears on the school war memorial. Another pupil at the school was the author C.S. Forester, who saw the name on the war memorial and used it as the name of the sea captain in his Hornblower series of novels.

DID YOU KNOW?
After the First World War, homeward-bound Canadian soldiers donated tents and sleeping bags to the Seaford Girl Guides, which they used to go on camp near Firle Place. Viscount Gage sent his gamekeeper over with a gift of nineteen freshly killed rabbits. The young girls then had to skin the animals and cut them up for their rabbit stew supper.

A Spaceship and a Hill Fort

If you follow the cliff edge to the west (looking back to see the iconic view of the Seven Sisters) you will pass Hope Gap, where there are steps down to the sea. At low tide you can still see the remains of a secret cross-Channel cable used by the Diplomatic Corps until the 1960s.

Further west is another dip which, although the nearby signpost calls it 'Buckle Church', is actually Puck Church. At one time there was a cave below the cliffs called 'Puck Church Parlour' where, in 1881, a local lad named John Costick died when he fell whilst collecting mews eggs. (A mew is a type of gull.) Previously, in 1836, another boy, Tom Cheal, had descended the cliffs here on a rope and entered the cave. He returned safely with three peregrine falcons.

Where did the name Puck Church come from? The name 'puck' is often used for a devilish sprite. There are reports of a hermitage here in the fourteenth century and an Elizabethan document refers to a church on the Downs at Seaford: indeed a church-like building is shown on a map of 1624. Could this have been the 'Puck Church'?

Inland you will see the South Hill Barn, also known as Beggars Barn. There is a car park here where there is often a refreshment kiosk. The origin of the name is interesting. In Victorian England there were a huge number of itinerant travellers, many of whom were soldiers discharged after the Napoleonic Wars. The Vagrancy Act of 1824 made it an offence to be homeless, so many of the men had a nominal trade such as 'knife sharpeners' or 'basket makers'. They would travel from place to place and sleep rough in farm buildings. A fire in a barn caused by a traveller's pipe could cause extensive damage so many farmers nominated a particular outbuilding for them to sleep. This may seem altruistic on the part of the farmer but it was actually a form of insurance.

Right: Puck Church.

Below: The South Hill or Beggars Barn.

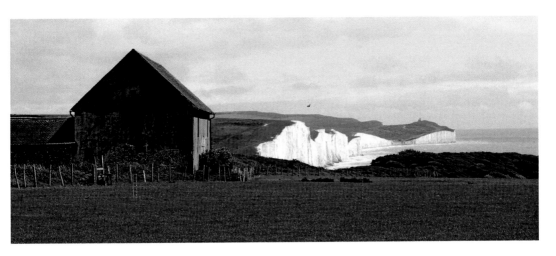

The cliffs here are slowly being eroded, making them dangerous, so do keep away from the cliff edge. In June 2017 there were three massive rock falls and in places the edge is just a few feet from the footpath.

As the downland fields on your right give way to the greens of Seaford Head Golf Course, you will notice in the bushes to your right that an alien spacecraft appears to have landed. Fear not, this is actually the Seaford DVOR run by National Air Traffic Services. DVOR stands for Doppler VHF Omni-directional Radio-Range. This device sends up a radio signal that enables aircraft to establish their exact position. In 1986 the old equipment was removed and is now on display at Seaford Museum in the Martello Tower.

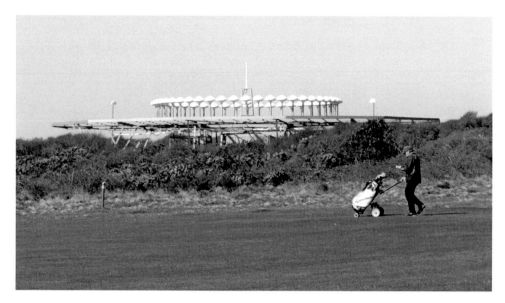

The DVOR Radar Station.

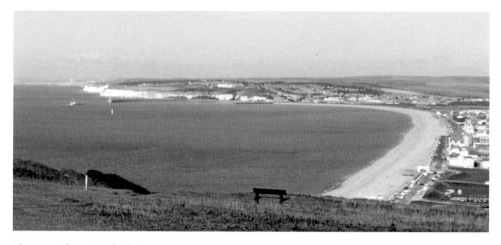

The magnificent Seaford Bay.

As you continue downhill with the magnificent 18th Green of Seaford Head Golf Course on your right, you are walking through an ancient hill fort dating from the early Iron Age (600–400 BC). This was built on an earlier Bronze Age settlement and there is evidence of a bowl-barrow (burial mound) and prehistoric roundhouses here.

This hill fort was excavated by the famous Victorian archaeologist Augustus Henry Lane-Fox Pitt Rivers (1827–1900) in 1876. At one time the fort was thought to be Roman and appeared on old maps as 'The Roman Camp'. There is plenty of evidence of Roman occupation of Seaford. Nearby, at the base of the hill, now under one of the golfing greens, was a Roman cemetery. In 2006 a secret hoard of twenty-one coins were found

by Mr David Lange near his home in nearby Blatchington. The now fragile coins were minted in Rome and date from AD 69 to AD 192. The coins are now on display at Seaford Museum.

The views across Seaford Bay here are spectacular and it is said that on a clear day the Isle of Wight can be seen. I am not sure how far you can see from here but people at Bembridge on the Isle of Wight claim to see Seaford Head on a clear day!

DID YOU KNOW?

The Seaford Bonfire Society were rekindled in 2011. Known as the Seaford Shags (after the name given to the wreckers of the eighteenth century), they attend bonfire celebrations throughout Sussex during the bonfire season, which runs from September to November. On the night of the Seaford Bonfire wreathes are laid at the war memorial before a procession to the Martello Fields, where a huge bonfire is built. The enemy of the bonfire is consigned to its flames. In 2012 they burnt a giant slug!

The Golf Club

In the 1880s a few men started to meet on the Downs above Seaford to knock a golf ball about. Their numbers grew and on 6 August 1887 a meeting was held where it was decided that a golf club should be formed. Among these early players were Mr John Fletcher Farncombe of Bishopstone and Mr Arthur Jack, who lived at the Crouch and owned the land where Morrisons supermarket is now sited. Other members included Mr William Lambe, who was an Overseer of the Poor for East Blatchington, and Mr Austin Leigh, who lived at Frog Firle and was a descendent of the author, Jane Austin. Major Crook of Telsemaure, Dane Road, was an early member as was Dr Pringle Morgan, who lived at Rostrevor, a house that formerly stood where Tesco is now situated and who practiced from Hurdis House in Broad Street. He was the doctor who first identified dyslexia.

These men must have worked hard in the next few weeks because they held their first general meeting in Seaford on 8 September 1887. The first president was a very distinguished person indeed, the Rt-Hon. Viscount Hampden GCB. The Viscount (Henry Bouverie William Brand) was the Lord Lieutenant of Sussex at the time of his appointment but had previously been an MP for Lewes and between 1872 and 1884 was the Speaker of the House of Commons. He lived at Glynde Place so presumably had a lot of space to practice his hobby at home.

One of the first members, Launcelot Harison, of Sutton Place agreed to lease some of his land on Seaford Head to this new club. The land, which ran from Chyngton Road to the cliff edge, had been occupied by a Mr William Bannister, a farmer who used the downland to graze his sheep. The new club worked around this and the sheep were useful in keeping the vegetation down.

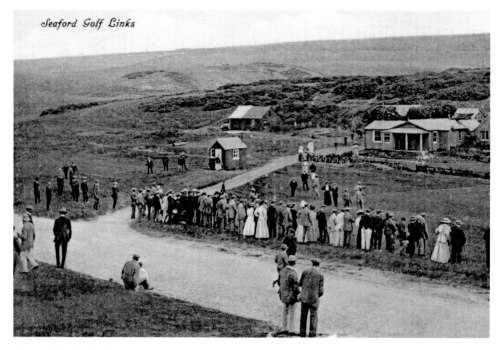

Seaford Golf Links

Early golf at Seaford.

The club hired a Mr John Thompson of Felixstowe to design the new course, which was to consist of twelve holes. A few years earlier Thompson had designed Aldeburgh Golf Course in Suffolk and it is interesting to note that his local course at Felixstowe has a link with Seaford in that both clubs have views over a Martello Tower.

After Brighton, this was the second golf course to be laid down in Sussex and was one of the first in the whole country; there were probably only about thirty or forty other courses in England at this time.

DID YOU KNOW?

When there was a request to play golf at Seaford on a Sunday in October 1894, the bailiff (mayor) said to the council: 'We don't want that class of man here who would play golf on a Sunday. A tradesman said to me the other day that a man who would play golf on a Sunday would not be too particular whether he paid his debts or not.'

The House on the Cliff

As you drop down into Seaford Bay you will be passing through the grounds of a lost but enigmatic building. There is little evidence of it today apart from some concrete groundwork and a red-brick wall which prevented residents falling off the cliff.

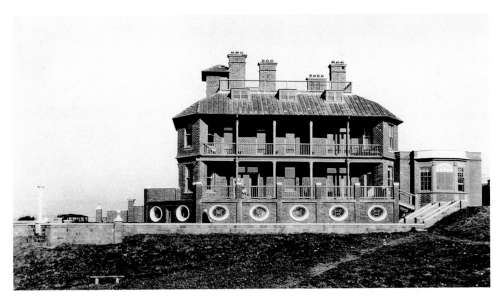

The House on the Hill.

Cliff Cottage was built in the last few years of the nineteenth century for a Mrs Maria Fleming Baxter, a London socialite whose father, Charles Hancock, was a jeweller famed for making the prestigious Victoria Cross (indeed, the same business still makes them today).

Reading Lynn Lawson's well-researched book *The House on the Hill*, it is clear that Maria supported women's health and suffrage. She was not keen on the restrictive dress code of the time and once modelled a mountaineering costume of knickerbockers and a short jacket. Her enlightened attitude is evidenced by the fact that, although happily married, it was in her name that the house was built.

After Maria's death in 1907, the house had several owners before it became a venue for the Friendship Holidays Association (FHA) in the 1930s. This organisation provided refined holidays, often in schools rented during the summer months. With the boost in motor cars and a huge interest in cycling, this was probably the heyday of the English holiday. Thousands flocked to the new holiday camps but the FHA provided a more genteel holiday, particularly for the many women left widowed by the Great War. Many new relationships were forged, so much so that the FHA was nicknamed the 'Find a Husband Association'!

Cliff Cottage was actually owned by the founder of the FHA and was a popular venue with its stunning views and access to the beach and countryside. Hundreds of people had a memorable stay in the house until the Second World War, when the buildings, along with many others in Seaford, were requisitioned by the army.

A lookout and machine-gun post were built into the red-brick wall and the house became a cookhouse for troops stationed along this part of the coast. There was also a radar station nearby 'protected' by a dummy gun emplacement made of wood. The real gun was well camouflaged and set into one of the slopes of the golf course.

2. The Esplanade

Splash Point

We have reached sea level but before we walk along the prom let's stop to look at the imposing cliffs of Seaford Head. A little known fact about Seaford is that it is the home to one of the largest colonies of Kittiwakes in Europe. The best time to see these birds is in July and often the RSPB will have a presence here; they may even let you look at the nesting birds through their high-powered binoculars. Kittiwake numbers in England have been declining in recent years but many of these hardy birds nest on the narrow ledges of the cliff each year. Unlike other gulls, the kittiwakes have black legs. If you are lucky, you may also see shags on the chalky outposts here. The shag is similar to the cormorant but has a prominent tuft on its head. You will occasionally see them with their wings outstretched to dry, having dived into the rough seas on a fishing expedition.

> **DID YOU KNOW?**
> In August 1833 it was reported that the crew of one of Mr Catt's fishing boats had landed an extraordinary fish. It apparently had the legs and arms (with hands and fingernails) of a human being and a pouch containing smaller fish on its breast. When it started to follow the fishermen around the ship they 'procured a weapon and dispatched it forthwith'.

Seaford Head.

Nearby is the closest Seaford will probably get to a pier. It is properly known as the 'Terminal Groyne' and was constructed in 1986 to hold back the movement of shingle from the beach. It was near here that a pretty young actress posed for photographs: Audrey Hepburn must have been freezing cold when these photos were taken in 1951.

On May Day 2017 an interesting artwork called 'The Shoal' was unveiled here. It is a cross between a sculpture and a memorial bench and consists of a number of beautifully worked fish intertwined to make a wonderful seating area. The artist responsible was Christian Funnell, who also made the 'Shag' sculpture that graces the River Ouse at Newhaven and also the monument in the Seaford Peace Gardens off East Street.

It was in this area that the River Ouse met the sea. The Romans and the Normans used Seaford as a port. It was one of the busiest in the country and in 1206 King John used Seaford to export materials to build a castle on Guernsey (Castle Cornet). The river slowly silted up and in the sixteenth century a new outlet was created at Meeching (now Newhaven).

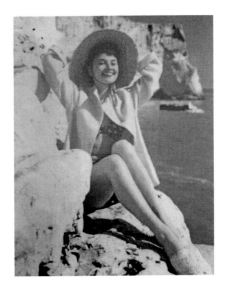

Audrey Hepburn at Seaford in 1951.

The Shoal Bench at Splash Point.

A Resilient Ghost

As you walk westwards towards the Martello Tower, past the brightly coloured beach huts, you will see the imposing building called Corsica Hall beyond the Martello Fields.

This large building started its life near Ringmer. It had been built by a man called John Whitfield who had made his fortune smuggling wine into the country from Corsica. On one occasion, when it appeared the excise men were too close for comfort, he made a generous offer of many casks of wine to George II and managed to escape punishment. When he died the house was bought by Lord Napier. In May 1772, Lord Napier's son 'accidentally' shot his tutor and, after the family moved out, it was said that the place was haunted by this ghostly teacher.

The house was later bought by a Lewes watchmaker, Thomas Harben. He moved the house brick by brick to Millburgh, the site of a former windmill here on the coast of Seaford. The next owner was John Purcell Fitzgerald but within a year he had knocked it down and the present Corsica Hall was built in its place. He lived here while he was MP for Seaford between 1826 and 1832, when the Reform Act stripped Seaford of its franchise. John was an interesting if eccentric person. His brother Edward was a famous Victorian poet and the translator of 'The Rubaiyat of Omar Khayyam'. He often stayed here and said of his brother, 'He was a man you could really love – at two and three quarter miles away!'

The building later became Seaford College, where one of the pupils went on to write a series of famous stories. Anthony Buckeridge studied here between the ages of 8 and 18, when he became a teacher at the same school. He wrote about some of the characters he encountered at the school, particularly one cheeky schoolboy called Jennings, named after his old school chum Diamaid Jennings. The Jennings stories were adapted for radio and television and became popular all over Europe between the wars.

Corsica Hall today.

Seaford College was evacuated to West Sussex during the Second World War and never returned. After a few years as a School of Housecraft, the building was divided into flats. Some say that the ghostly teacher still haunts the corridors, but he must be a particularly resilient ghost as his death occurred miles away and in a different building!

The Tardis

The first visit to Seaford Museum is always a surprise – it is much bigger on the inside than it looks from the outside! The museum is not only housed in the Martello Tower but also across half of the moated area too.

Martello Tower 74 was constructed between 1805 and 1808, the last in the chain of small defensive forts designed to counter any invasion attempt by Napoleon. The tower was built in a deep hole dug into the shingle so that only the top part and gun would be visible to the enemy. The tower was built from around 700,000 London bricks which have a yellow hue and were bought from the Tower Wharf in London by barge. The tower was surmounted by a 24lb 'long cannon' (larger than the cannon which is now in place). History books report that the cannons on the Martello Towers were never used in anger but I do not think this was the case in Seaford. The prevalence of French privateers along the south coast in the early 1800s leads me to believe that it is highly likely that the cannon on Seaford Martello Tower would have fired upon them On 14 December 1810, three French ships fired at the Seaford coast and around fifty people walking along the beach had to dive for cover. I am sure the tower would have returned fire.

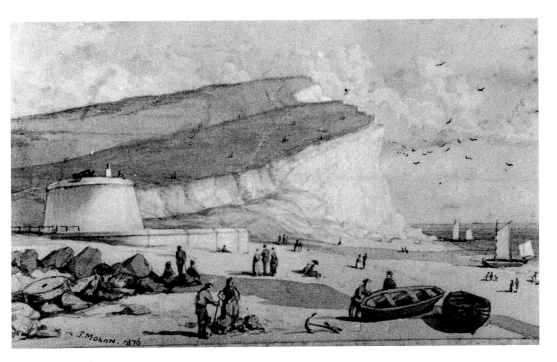

The Martello Tower.

The tower would have housed around twenty-four men, although, as there was a large battery adjacent, it is unlikely that the men actually lived in the tower; unlike the other towers which stretch around the south-east coast from Suffolk, there is no record of people living in the tower during the regular census returns.

Seaford Museum was established in 1971 and was originally housed in a caravan which toured the town, visiting schools and fêtes. It later moved into West House in Pelham Road, the home of Joan and Ken Astell. In 1979 the council offered the museum a new home – the Seaford Martello Tower. Despite the tower being rather dark and damp, it became a good home and attracted 4,000 visitors in the first year. The trouble was, there was far too much room; so a call went out for people to donate items for display. This is why today the museum has such an eclectic collection of – stuff! The museum's collection includes exhibits that range from fossils which are millions of years old to mobile phones and computers. The museum has plenty of maritime and military items reflecting the history of the town. One unique exhibit is the collection of fourteen hand axes that were found in the High Street in 1987. These beautiful worked flint tools are actually the largest hoard of British flint hand axes found anywhere in the United Kingdom. The reason they were buried together some 3,000 years ago is unknown.

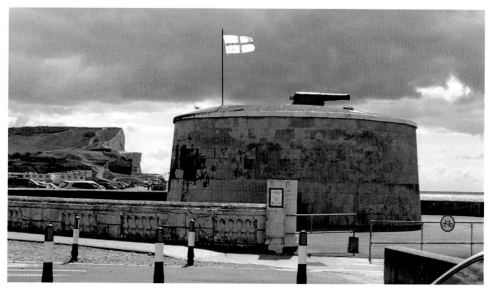

Seaford Museum.

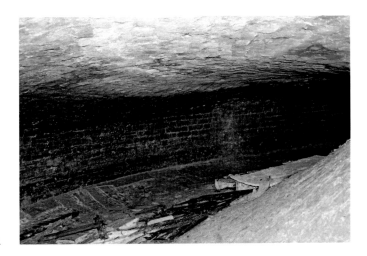

Under the Martello Tower.

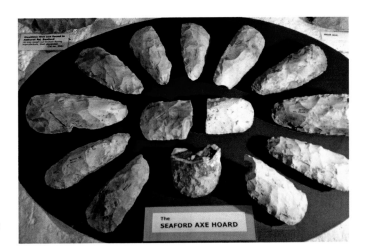

The unique hoard of flints
at Seaford Museum.

The axes are displayed in one of the recesses of the magazine – the room where gunpowder was stored. A hole in the back of the alcove would have taken away the blast of gunpowder should the room explode. The wooden trapdoor nearby led to a sump of water which would have also helped to restrain any explosion. I have been lucky to explore this underground brick cellar – a secret part of the museum that very few people have ventured into. In this gloomy and rather musty space I was able to see how the building was constructed of thousands of bricks which is not apparent from the outside. It was quite claustrophobic to be under the vaulted mass of bricks but a unique experience.

The museum also has recreations of local shops, including a camera shop and even a cinema. However, there is a lot more to Seaford Museum.

When I first started volunteering at the museum over twenty-five years ago I worked with the 'Housing Register'. It was the aim to have a record of not only every street in Seaford, but every house too. Today, volunteers continue this work and the archive has maps, photographs and estate agent details covering the local area. The archives are open

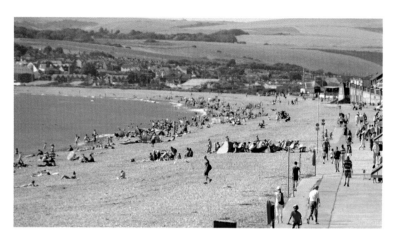

Seaford's 'new' beach.

regularly for the public to come and browse the collections (see the museum website www.seafordmuseum.co.uk for details.)

A film shown at the museum explains Seaford's biggest secret – its beach. Climb to the top of the tower and you get a great view along Seaford Bay towards Tide Mills and Newhaven. However, this is not a natural feature; in fact when you walk on the seashore you will be walking on a beach that is half Spanish and half Bognor!

There have been attempts for hundreds of years to hold back the constant tides in Seaford Bay. Flooding was a regular occurrence. During a storm in 1875 the seawater lapped at the door of St Leonard's Church. Various sea defences were tried but, in time, the incredible power of the sea crushed the concrete as if it were matchwood. The regular flooding not only caused damage but delayed through-traffic. It also meant that a large strip of land facing the sea was unfit for occupation.

DID YOU KNOW?

In June 1947, the national press reported the death of a Seaford cat named Wendy. She had been recorded by the BBC when they visited Seaford to report on sea defences and was famed as being Britain's only talking cat.

The solution was agreed in the 1980s. The whole of the beach at Seaford Bay would be filled-in, thus doing what King Canute was unable to do – hold back the tide. Tonnes of granite blocks quarried from northern Spain were used as a base then topped up with many ship-loads of shingle dredged from Owers Bank, just off Bognor Regis. The Terminal Groyne was built under Seaford Head to hold it all in place and the old wooden groynes were buried. The work was completed just in time for the Great Storm of 15–16 October 1987 – Seaford held its breath and although there was considerable damage to trees and buildings, the new beach stayed firm.

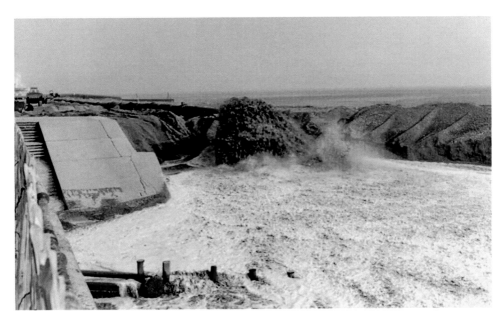

Creating the new beach in 1987.

The swirling tides still move the shingle along the beach, but every Spring and Autumn heavy trucks and bulldozers restore order. Many local people, especially older residents who remember sitting under the shade of the groynes, do not like the new beach, but as far as the Environment Agency are concerned it is not a beach – it is Seaford Sea Defence and as such it has served the town well for the past thirty years.

As I am writing this, Seaford Museum is in the process of building an entrance ramp and a lift to make the tower more accessible than at any time in its 200-year history. In 1903 the tower was described by a local councillor as 'a giant dustbin' and a 'pimple on the face of nature'; however, Turner Prize-winning artist Grayson Perry has since described it as 'one of the best museums in the world'!

The Esplanade

As we walk westwards along the bay you will see houses and flats on the right built after the 'new beach' was created. Close to the sun-shelter is a direction finder, built in 2014 as a memorial to Claire Ivory, a past president of the local Rotary Club. As you look at the plaque you probably won't realise that you are standing on 'The Cheese', a wedge-shaped set of steps that once led down to the beach, which, prior to 1987, was many feet below. Children once used this as a base to dive into the sea at high tides.

Further along the Esplanade, close to the second sun-shelter, we come to the junction of The Causeway which leads down to the Wellington Pub. The Causeway once led over the marshy bed of the old River Ouse.

The Wellington Pub was originally named The New Inn but changed its name after the Duke of Wellington stayed there on 6 October 1845. He visited to survey Seaford Bay as a potential 'Harbour of Refuge' for the Royal Navy.

The Rotary Memorial.

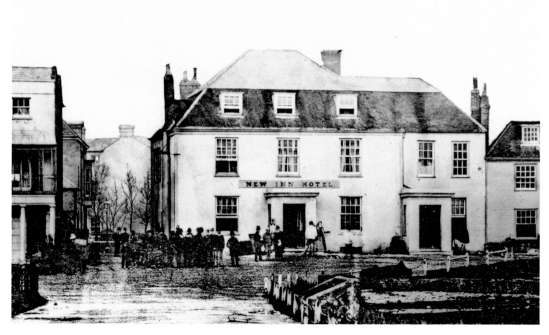

The New Inn.

The buildings on the seafront here were the site of the Assembly Rooms and Public Baths which were built in 1870 by property developer Dr William Tyler-Smith. They boasted 'sea-water baths', which seems odd considering how close they were to the sea!

The buildings were demolished in 1891 to make way for the modern Esplanade Hotel, which could accommodate over 100 guests. A 1901 guidebook boasted that it was 'one of the brightest and most comfortable hotels on the south coast' adjacent to the 'newly built 2½ mile long "Marine Walk"'. Newspaper adverts proclaimed that Seaford was 'sunny with cool breezes and no fog'! The hotel had a lift to all floors and in April 1901 the manager, Mrs Hindle, was killed when she fell down the lift shaft. Within a few days of the inquest being told that the lift was safe, a 15-year-old lift attendant, Edwin Baldwin, also fell down the lift shaft and was killed.

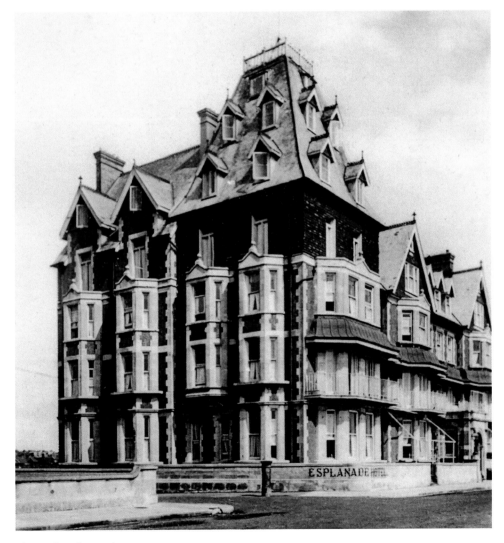

The Esplanade Hotel.

In 1905 the Duke and Duchess of Sparta (later King Constantine and Queen Sophie of Greece) stayed at the Esplanade Hotel. King Edward VII also visited the same year but he only stayed for lunch and presumably didn't use the lift! The hotel stood here until 1976, when it burnt down.

A Brave Seafordian

The buildings that stand on the site now are on Mallet Close, named after a remarkable life-safer, Richard Mallet. He spent his early years in the Royal Navy, where he received accolades for rescuing men from the sea in the Far East and the Baltic. He retired to Seaford but his brave service continued as a member of the local Coastguard Service. On 16 December 1869 he was called to the seafront, where a French ship called the *Seraphine* had floundered. Mallet secured a line to his waist and jumped into the cold and stormy seas to rescue the crew of nine. One by one the crew made the treacherous journey along the line to the shore, where coastguards were waiting to assist them. On several occasions Richard was lost from view under the crashing seas but managed to survive the ordeal. Unfortunately, the youngest member of the crew, a cabin boy, fell from the line and was pulled under the stern of the ship and drowned. Within twenty minutes the ship was destroyed.

Mallet was feted for his bravery and local people raised money for a reward. He was presented with a gold watch, a gold medal by the French government, and the Royal Humane Society medal.

Further up the Esplanade, near the deckchairs of Frankies Café, stood the Seaford Bandstand. There are few pictures of the bandstand, which was in place until 1923. As you walk along you should also note the Seaside Beach Garden decorated with an old rowing boat on your right.

Dane Road is probably named after a stream 'The Dann' which came out to sea here. On the right-hand side of the road stood Telsemaure, a large house built by Thomas Crook. Crook had visited Seaford on a number of occasions as a Major in the Honourable Artillery Company, who regularly used the town for their summer camps. He fell in love with Seaford and built a house here in 1861. Telsemaure was named after members of the family – Thomas, Elizabeth, Lewis, Sarah, Emily, Mary, Anne, Upham, Ruth and another Elizabeth.

Crook provided Seaford with its first gasworks (in Blatchington Road), and his house on the seafront was one of the first to be lit by gas. The house has long since gone but there is a reminder of the Second World War on the nearby wall. It is still painted with the black and white 'blackout' markings!

On the other side of the road, on the land now occupied by retirement flats, was Seaford's last seaside pub, the Beachcomber, which was demolished in September 2012. This section of the Esplanade once boasted a flagpole, toilets, a shelter and a telephone box until a storm in 1936 demolished them. This was also the location of the graceful figurehead of the Peruvian ship which was wrecked near the Martello Tower in 1899. She stood here for many years until being relocated to the playground of Chyngton School. She has since received a well deserved makeover and is now in the care of the Museum.

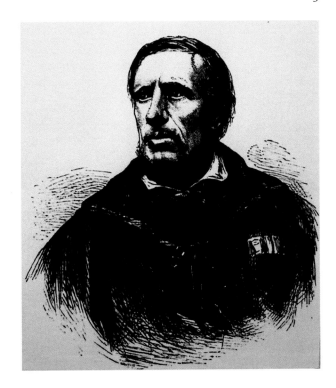

Right: Richard Mallett –
a local hero.

Below: The bandstand.

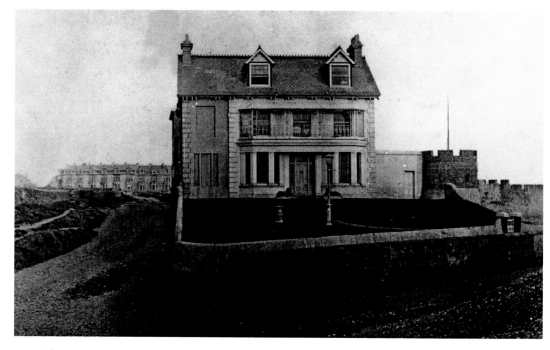

Telsemaure.

Marine Parade

The road now becomes Marine Parade and on the right is the Salts Recreation Ground and playing fields, home to Seaford Rugby Club. This large flat area was once one of many saltpans along this section of coast. When these fields were flooded, a few inches of water would be captured and allowed to evaporate, leaving a thin layer of precious sea salt – an important commodity in medieval times as it was used to preserve fish and meat. There was once a paddling pool, putting course and pond for sailing toy yachts here. Today there is a popular café, tennis courts, a skateboard park and an open-air gym.

When Marine Parade reaches Edinburgh Road the seaside path splits. The lower level is called Bonningstedt Promenade, named after Seaford's twin town to the north of Hamburg in Germany. A plaque halfway along commemorates this. There is also a plaque to commemorate the men from Northern Ireland who trained in Seaford during the First World War.

> DID YOU KNOW?
> There are other Seafords around the world, most with a direct link to our own town. For instance, Seaford in Delaware, America, is close to Newhaven and Lewes and is in County Sussex. There are also Seafords in New York State (America), Jamaica and Australia.

The Salts.

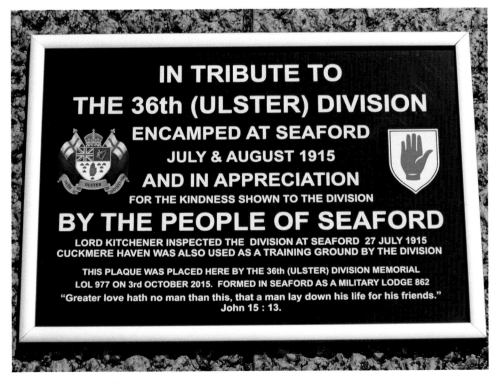

IN TRIBUTE TO
THE 36th (ULSTER) DIVISION
ENCAMPED AT SEAFORD
JULY & AUGUST 1915
AND IN APPRECIATION
FOR THE KINDNESS SHOWN TO THE DIVISION
BY THE PEOPLE OF SEAFORD
LORD KITCHENER INSPECTED THE DIVISION AT SEAFORD 27 JULY 1915
CUCKMERE HAVEN WAS ALSO USED AS A TRAINING GROUND BY THE DIVISION

THIS PLAQUE WAS PLACED HERE BY THE 36th (ULSTER) DIVISION MEMORIAL
LOL 977 ON 3rd OCTOBER 2015. FORMED IN SEAFORD AS A MILITARY LODGE 862
"Greater love hath no man than this, that a man lay down his life for his friends."
John 15 : 13.

The Northern Ireland Memorial.

The upper level takes the cycle path over the hill. The roads on the right were due to be an estate named after Queen Victoria and her family. Edinburgh Road was named after Prince Alfred, Duke of Edinburgh, Queen Victoria's second son. Connaught Road runs from the seafront here to Claremont Road and is named after the Duke of Connaught, Queen Victoria's third son. The land was originally part of the East Blatchington Estate and in the 1870s, when a development here was first mooted, a wave of patriotism for the Queen ensured that all the proposed roads had royal names, indeed the area was due to be called 'Queen's Park'. A plan of 1873 shows that Connaught Road was due to be intersected by Victoria Road, Albert Road and a rather grand Alexandra Crescent; however, only Connaught Road, Edinburgh Road and Albany Road (named after Prince Leopold, the Queen's fourth son) were built.

Mutiny!

The land between Connaught Road and Claremont Road was the location of the 'West Gun' which, due to the eighteenth-century Napoleonic threat, expanded to be the Blatchington Barracks. Hundreds of men from all over England, Scotland, Wales and Ireland spent a miserable few months here in anticipation of a French invasion.

The conditions at Blatchington Barracks in 1795 were appalling. Over 1,000 men were living in the fort, which was designed to house just 600. Many were living under canvas and the food was overpriced and poor. On Thursday 16 April, some men marched into Seaford from their base and raided a butcher's shop. Officers followed them and

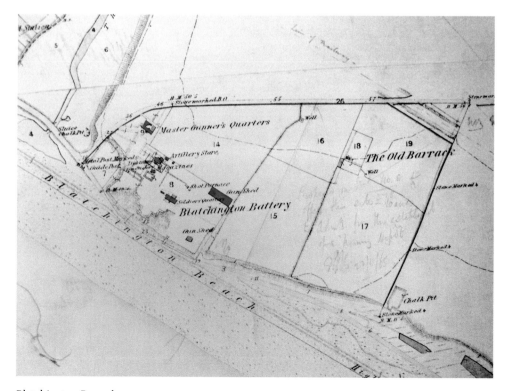

Blatchington Barracks.

persuaded the men to return to barracks. The next morning even more men marched to Seaford and again shops were looted. They were met by the Bailiff (Mayor) Thomas Harben, who was also the Captain of the Seaford Volunteers. He tried to placate them by offering to pay for the food they had looted. The men refused this offer and turned back towards Newhaven, passing their barracks and taking wagons and horses from local farmers. At Tide Mills, the men commandeered a sloop called *Lucy* and filled it with around 300 sacks of flour from the mills. Edmund Catt, the owner of the Tide Mills at this time, had the contract for supplying flour to the Royal Navy and there were frequent sailings between the mills and Portsmouth.

Some men then managed to sail the ship the short distance to Newhaven Harbour, while others marched around to the port. The flour was unloaded, with some sacks being put into storage and others being offered to local people at a 'reasonable amount'.

At 10 a.m. the local parish constable sent a message for help to Lord Sheffield (John Baker-Holroyd), who at that time was sitting at the Lewes Assizes. He requested General Ainslie (probably George Robert Ainslie 1755–1802) – who was commander of the area – to intervene. He in turn ordered twenty-four dragoons of the Horse Artillery to Newhaven. These were led by Major Henry Shadwell. Lord Sheffield and General Ainslie were probably not aware of how serious the situation had become for it seems foolish to send just twenty-five men to quell a possible rebellion of over 500 disgruntled soldiers. When they arrived in Newhaven, Shadwell and his men were surrounded but he bravely agreed to go alone with the men to discuss their grievances.

Major Shadwell was pushed and pulled around by the mob, many of whom were drunk, but he arranged to meet a representative of the men at the Ship Inn at Newhaven. He found a pen and paper and went into a small room at the inn, where he met Captain Edward Cooke. Cooke had been chosen by the men to represent them; he was also the cook at the barracks and well placed to know the problems in trying to cater for men using overpriced and poor quality food. Cooke was a blanket weaver from Witney in Oxford.

Unfortunately, the meeting ended without compromise and Lord Sheffield himself rode to Newhaven to assess the situation. The result was that the following morning (Saturday) a force of Horse Artillery and Lancashire Fencibles were sent from their barracks in Brighton to take control. Armed with two small cannon they met a group of mutinous Oxfordshire men who had swords and guns but no ammunition and, after a skirmish lasting about an hour, the men were disarmed. Twenty-five were arrested and the rest returned to their barracks. Captain Harben went to the barracks with his Seaford men and they took over the running of the base. Lord Sheffield also took the precaution of mooring a military vessel nearby in case there were further problems.

It is interesting to wonder how this uprising was considered by the local people. Many of the shopkeepers would have lost their stock during the looting, but one cannot help think that they were partly responsible by profiteering from the troops by selling the army overpriced and poor food in the first place. The fact that the mutineers sold some of the looted flour on shows that some local people were willing to trade with the men and were not frightened of the situation. In Lewes, however, the local inhabitants were so pleased that the rebellion was over that they had a collection and gave over £50 to the men of the Artillery and Fencibles for their actions.

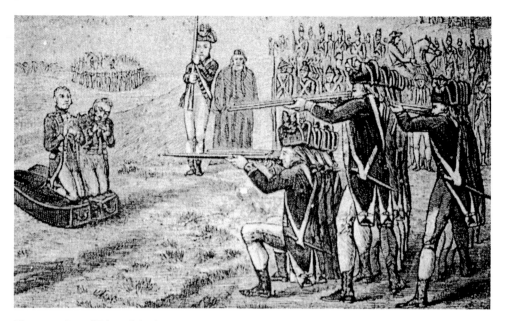

The execution of Edward Cooke.

The government were quick to ensure that similar problems did not occur elsewhere and within a few days it was announced that there would be a standard rate for the purchase of bread and beer for the army.

The matter ended with a court-martial for the men who had been arrested. This took place at the Old Ship Tavern in Brighton and consisted of thirteen officers from various regiments. It cannot have been reassuring for the prisoners to see that two of these went by the names of D'eath and Bastard (Lieutenant Colonel D'eath of the East Kent Regiment and Lieutenant Colonel Bastard of the East Devon Regiment).

Unsurprisingly, the men were all found guilty and received the death penalty. However, most were reprieved and received a public whipping. Records show that a Private Blake was given 1,100 lashings. Henry Brook and John Etherington, who were not soldiers but had been caught up in the incident, were found guilty of looting and were transported for seven years. Edward Cooke was executed with a fellow militiaman on 13 June 1795 at Goldstone Bottom in Hove. In his last letter he wrote, 'I am not afraid of death for I have done no harm to no person'.

DID YOU KNOW?

On 1 July 1784 a three-hour battle took place off Seaford between smuggling ship *The British Lion* and the *Flirt*, a government sloop-of-war which fired over 400 shots. The smugglers fired bolts, nails and even horseshoes to cut the sails of the *Flirt* and several sailors were wounded. Cries from the smuggler's vessel indicated that several of its crew were also injured but they managed to get away.

Threat of Invasion

In November 1798 Blatchington Barracks were taken over by the Derby Militia and the officers gave a Christmas Ball for the ladies of Seaford. It was reported that this event was so successful that it did not break up until 6 a.m. the next morning. Two of the officers who put on this Ball found themselves at loggerheads a few weeks later and fought a duel on the beach nearby. One man received a wound to his head but recovered and honour was restored. This is the last record of a duel being fought in the area.

Around the year 1800 a Colonel Coote Manningham arrived at the barracks. Manningham had served in the army in Gibraltar and had also seen service in the West Indies, where he had received a wound. In 1799 he raised an experimental corps of men who were equipped with the new 'Baker' rifle. Although named the 95th Regiment of Foot, the men were to become the Rifle Corps. They were initially nicknamed 'Manningham's Sharpshooters' but later became known as the 'Green Jackets' after the colour of their uniform – green so as to blend in with undergrowth when they were sniping. The first headquarters for this regiment was here at Seaford, indeed the first Regimental Orders were entitled 'Regulations for the Rifle Corps formed at Blatchington Barracks under the command of Colonel Manningham'. A year after their formation, the men fought alongside Nelson when they served with the Navy at the Battle of Copenhagen. It was here that the regiment received their first casualty when First-Lieutenant Grant's head was severed by a cannonball on board HMS *Isis*. The captain of the *Isis* at this engagement was Admiral James Walker, a Seaford man whose tomb can still be seen in St Leonard's churchyard.

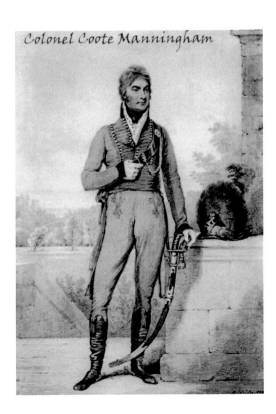

Colonel Coote Manningham.

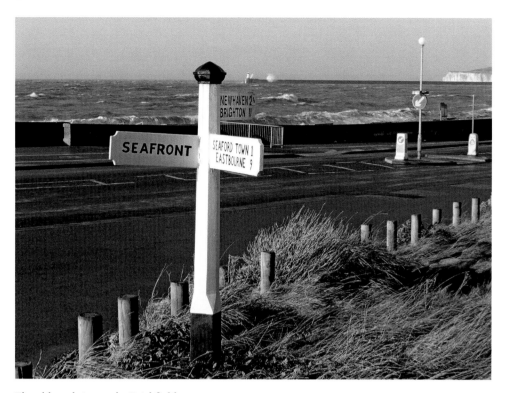

The old road sign at the Brickfield.

The Rifle Brigade went on to be a stalwart of the British Army and their battle honours include Waterloo and other locations around the world including Spain, South Africa, India and even Brazil. They fought at Gallipoli and El Alamein and are now known as the 'Royal Green Jackets'. It is satisfying to note that this famous and distinguished regiment were formed in Seaford.

After the victory at Waterloo in 1815 the threat of invasion diminished. The last troops to be based here were the 2nd West Riding of Yorkshire Regiment in 1816 and two years later the entire contents of the barracks were sold in four auctions.

The Brickfield

At the junction of Claremont Road (named after the local landowner, Lord Pelham's country house in Surrey) is a white 'fingerpost' traffic sign which was placed here in the mid-1930s. At the time, before the Buckle bypass opened in 1964, this was the A259 and the main road between Newhaven and Eastbourne. In 2012 the sign was in a sorry state but luckily was restored by a local artist, David Taylor.

David is also a founder member of the 'Friends of the Brickfields', which is the scrubby area of land adjacent to Claremont Road. It is not known when bricks were first made in Seaford as there appears to be little documentary evidence. A correspondent to Seaford Museum in 1982 suggested that the brickworks here were responsible for making many of the red coloured bricks of the Martello Tower moat walls, although the yellow coloured

ones for the tower would have been brought from London. It is also likely that bricks made here would have been used for the adjacent Blatchington Barracks, which was completed in 1795.

The handmade bricks would be laid out for drying on 'hack boards'. This would take up to six weeks, although after two weeks the bricks would be dry enough to be moved and would be laid in herringbone layers. They would also be regularly turned to ensure an even shape.

The last process was firing the bricks, which would be laid side by side to form a huge flat-topped pyramid or 'clamp'. The clamp could contain between 50,000 and a quarter of a million bricks and it would be a skilful job to ensure that the fire within burned steadily and evenly over several weeks. A change of wind would mean that some vents would have to be blocked to prevent the internal fire from burning out, so an assistant brick maker would be on-hand 24 hours a day to ensure that everything ran smoothly.

The correspondent to Seaford Museum recalls that when the brickfields here regularly flooded with seawater, huge clouds of steam would be seen above the site, which apparently continued to produce bricks until the 1920s.

Alas, today there is no sign of all this activity but that does not mean it is not worth a visit – quite the contrary. The brickfield is now a wildlife haven, home to shrews, voles and field mice which in turn provide food for the kestrels that nest nearby. A wetland area was created (known locally as 'The Dip') and frogs, toads and newts have made their home here. There is also an abundance of flora to be seen. The 'Friends' still regularly hold events here.

The Brickfield.

The Buckle

Further along the seafront towards the Sailing Club is a car park. Lewes District Council proposed selling this land, previously a council depot, for development in 2015 but there was so much local opposition that the scheme was dropped. Photographs from the late 1800s show railway lines here; small engines almost certainly being used to move shingle and other material along the seafront for sea defences.

There was another type of sea defence during the Second World War. A chain of barbed wire and huge concrete tank-traps protected the coast from German invasion. One of these large concrete lumps (known as 'dragon's teeth') can still be seen in the north-west corner of the car park. This was one of thousands that stretched along the bay to prevent German tanks from landing. A Council Engineers' report of 1946 states that there was a large stock of them here and they were subsequently gathered up and concreted into the seawall.

The Church of St Michael in the High Street, Lewes, contains some interesting memorials including that of Sir Nicholas Pelham (1515–1559). This splendid monument shows Pelham at prayer with his wife Anne Sackville above his children, all kneeling on cushions. The memorial is in the form of a Tudor pun: 'What time the French sought to have sack't Seafoord, this Pelham did repel them back aboord'.

The area where this engagement took place is called 'The Buckle'. According to family tradition, an ancestor of Sir Nicholas, Sir John Pelham, was present at the Battle of Poitiers in 1356 and after he captured the sword of the King of France was given the sword's strap as a memento. Recently, however, historian Peter Robinson has put forward a more likely

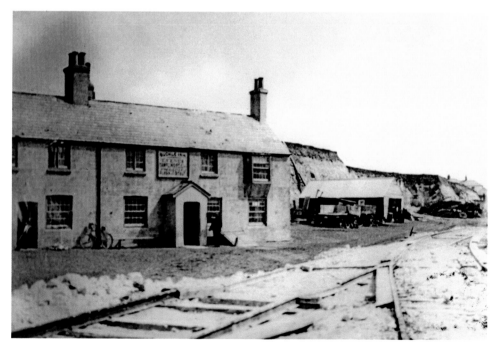

The Buckle Inn.

A wartime sea defence.

reason why the buckle became a Pelham symbol; although there is no record of Sir John being at the Battle of Poitiers, he was made 'a Knight of the Household and Royal Sword Bearer' in October 1399. In any case, the buckle soon replaced the pelican on the family coat of arms.

On 18 July 1545, a French fleet led by the High Admiral Claude d'Annabant attacked the south coast of England. He was rather annoyed that the English had just captured the port of Boulogne and was after revenge. At Portsmouth, Henry VIII's ship *Mary Rose* had promptly sunk as it tried to engage them. Further down the coast the French attacked Brighton and Meeching (now Newhaven) before coming ashore here in Seaford Bay, where they 'set certain soldiers on land to burn and spoil the country'. But us Sussex folk 'will not be druv' and were having none of it! One chronicler said: 'the beacons were fired and the inhabitants thereabouts came down so thick that the Frenchmen were driven to fly with loss of diverse of their numbers, so that they did little hurt'. Another account says the French were 'met with such manful resistance... they were fain to betake themselves to their ships and galleys and to retire with considerable loss to their own side'.

It is estimated that 1,500 Frenchmen landed and they burnt half a dozen cottages at 'Blechington Hille' before they were repulsed by Pelham's rag-tag army, which consisted of local townsmen, gentry and yeomen who were presumably getting fed up with the regular incursions by the French, who had been attacking the Sussex coast since the fourteenth century. It is not recorded how many Sussex men lost their lives in this skirmish, but over a hundred Frenchmen were either killed or drowned. The local people were relieved by this victory and Sir Nicholas became a local hero. The area where the attack took place was named after the Pelham symbol and is still to this day known as 'The Buckle'.

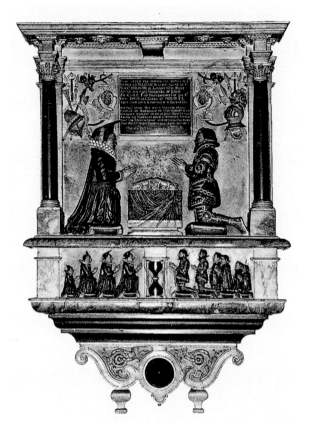

Left: The Pelham Memorial at Lewes.

Below: The Old Buckle Inn.

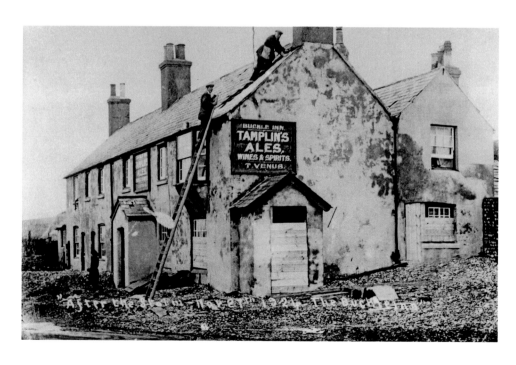

No one knows when a pub appeared on the site of the battle, but it took the name of the Buckle Inn. The pub was precariously sited under the cliffs of Hawth Hill. Traditionally candidates for the regular (and rotten) Seaford elections would arrive at the Buckle Inn, where their carriages would be adorned with bunting and flowers. The horses were replaced by local townsfolk who would pull them into town themselves, often accompanied by a band. When the railway cut through Hawth Hill in 1864, the nearby bridge was named the 'Buckle Bridge' and when East Sussex Council decided that Seaford needed a bypass in 1948, the road was named the 'Buckle Bypass' – although it was not built until many years later in 1964. By the way, 'hawth' is a Sussex word for gorse.

The Buckle Inn was regularly damaged by incursions of sea during high tides. Indeed at one stage, before the bypass was opened, the landlord would throw an electric switch in the building which turned on a sign on the main road warning motorists to avoid the seafront. Traffic then had to head through Seaford on an inland route (which we will visit later). I once spoke to a gentleman who recalled drinking in the Buckle Inn and having to lift his feet off the floor in order to avoid the incoming waves.

The pub was demolished in favour of a modern Buckle Inn in 1962; this consists of a large round tower, echoing the shape of the Martello Tower (Seaford Museum) at the other end of the Esplanade. The building is now a splendid private home and Bed & Breakfast. An information plaque is located nearby to recall the battle of 1545.

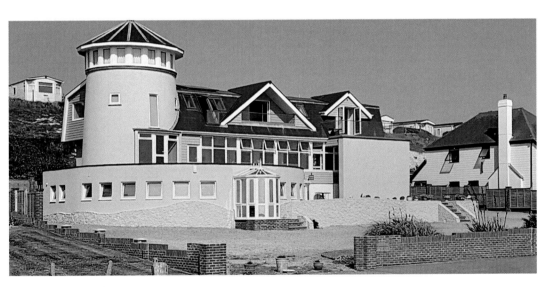

The new Buckle.

3. Bishopstone

The Sailing Club is often open for refreshments but we will follow the road inland. Take a good look at the Buckle Railway Bridge, as there is more to it than meets the eye.

The bridge was built in 1864 on land owned by William Tyler-Smith, who had instigated the extension of the railway from Newhaven to Seaford. Prior to this, the London Brighton and South Coast Railway (LB&SCR) only ran trains as far as Newhaven. However, following a series of meetings with Tyler-Smith, in November 1860 they announced the building of an extension from 'Newhaven Wharf Station to a point 80 yards from the Parish Church at Seaford.'

On leaving Newhaven, an embankment was needed to keep the track above the flood plain of the old River Ouse. As the line got to Hawth Hill it crossed Marine Parade here. The railway then ran along a 36-foot-deep cutting to Seaford. Sadly, three men were killed during its construction.

The line opened on 1 June 1864 – with free rides for everyone. There were processions and a formal dinner at Seaford. The Tide Mills were bedecked with bunting, and with bunting and ships at Newhaven Harbour and in the bay 'formally dressed' for the occasion.

The original railway bridge was built of brick with a 28-foot-high arch, but on 24 July 1904 the line between Newhaven and Seaford was doubled and so the bridge was extended on the landward side – this is clearly seen when you pass under the bridge as

The Buckle railway bridge.

the brickwork on the sea-side is much older. You will also notice parts of the bridge have been repaired with patches of new red brickwork. This was where the Seaford Home Guard placed explosives during the Second World War in order to blow up the bridge should there be a German invasion (thus denying the occupying forces all of about three quarters of a mile of railway line!).

Bishopstone Station

A set of stairs adjacent to the bridge leads up to Bishopstone Station, now an unstaffed halt.

In the mid-1930s there were proposals to develop the Hawth Hill area of Seaford and, due to the potential increase in residents, the Guildhall Development Company decided to build a new railway station between Bishopstone Beach Halt (Tide Mills) and Seaford Station.

Plans for the new station were developed by the Southern Railway architects at Waterloo and it was decided that the station should have a modern Art Deco look. The design is similar to that of Arnos Grove in London, designed by Charles Holden who was responsible for many London Underground stations. Although there is no evidence to show that Bishopstone Station was actually designed by Holden, there is no doubt that the architects were influenced by his work.

The station was designed around an octagonal booking hall with projecting wings and rounded brickwork; typical of 1930s design. One wing contained a ticket office and a large parcels area. The wing opposite had ladies' and gentleman's toilets, a waiting room and a small bookstall. The glazed booking hall was tall with a glass-tiled ceiling to allow in natural light. A small lobby led to a glazed footbridge with steps leading down to the two platforms. The platforms each had a canopy and a waiting room and the 'Up' platform

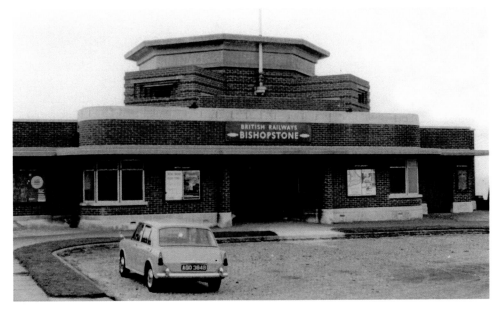

Bishopstone Station.

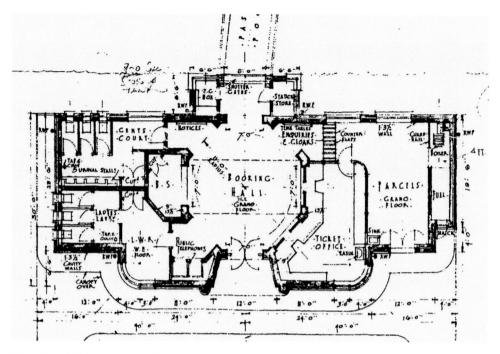

The original Bishopstone Station plan.

even had a small office for railway staff. There was one extra line used as a siding. At the front of the station the plan was to have large modern lettering spelling out 'Southern Railway' on the tower and a flagpole.

There was some opposition to the building of the new station; the *Sussex County Magazine* regretted the development of the area, saying that as a result the old village of Bishopstone with its beautiful church 'may be swamped with modern buildings'.

The new station was opened on 26 September 1938 and on the same day the old Bishopstone Beach Station was closed. The modern new station was built of brick and concrete but soon had to be altered due to the demands of war. In 1940 the octagonal tower was turned into a well disguised military pillbox. It had two projecting areas, each having recessed gun-slits facing both towards the sea and inland. This part of the new design is similar to that of a Type 27 Pillbox, which was a brick-built, octagonal, fortified structure usually used to defend airfields. A small military camp with an anti-aircraft gun was built to the south of the station on the area now occupied by a caravan site and the station was busy with the comings and goings of soldiers based there.

Southern Railway appointed a female stationmaster, which was most unusual at the time. She was Mrs E. Moore and in a wartime propaganda film she is seen selling tickets, talking to passengers and waving her flag to see off trains. The film was used to encourage women to take up work traditionally done by men. Mrs Moore had previously been a stewardess on the steamship the *Brighton* and she remained on the ship after it had been requisitioned as a wartime hospital ship. In 1940 the ship was bombed whilst in Dieppe Harbour but Mrs Moore managed to escape into France, where she hid in hedges,

Bishopstone Station
pillbox.

walking 40 miles to Fecamp. Here she managed to board a coal ship, which dropped her off in Cornwall. After all that adventure, Bishopstone Station must have been quite dull!

There were plans to close the station in the 1960s during the Beeching Cuts but a committee headed by local resident Harry Potter ensured that it stayed open. The last member of railway staff to work there was Mrs Una Shearing, who worked from the platform office until 1988.

The station is now a Grade II listed building. Before you leave and return to the road take a while to look at the view from the footbridge. I have spent many hours here waiting for trains! I am minded of a poem by A.J. Clifford published in 1971:

<div align="center">

So many times, I've stood alone
upon the bridge at Bishopstone
And gazed upon the ships at sea
and at the downland scenery
Wondering if anywhere
another station could compare
With this small isolated halt
for views that have so little fault.

How different to the underground
where all that one can see around
Are posters and advertisements
for bingo, beer and detergents
Oh! How much worse off I would be
if that were all I had to see
Instead of standing all alone
upon the bridge at Bishopstone!

</div>

A Small Building That Held a Big Secret

Beyond the railway bridge on the left is a small brick-built hut set back from the road. Few people realise the secret that this unassuming building once held.

I have mentioned that this area has been under threat of invasion on many occasions and that during the Second World War, Seaford coastline was covered by sea defences that included concrete blocks and miles of barbed wire.

Should the enemy arrive in Seaford Bay there was a plan to pour oil into the sea and set it alight. Experiments were done at Newhaven Harbour and proved to be successful. Two massive oil tanks were installed at Bishopstone with two long pipelines passing under the A259 to this spot at the Buckle Bridge. The small brick bothy was designed to hold the valves which would have been opened to allow the oil to pour into the sea. The pipes would have gone under the railway bridge and out to sea close to the present-day sailing club.

One man who remembers this unlikely sea defence is Gordon Cornford, who lives near Maresfield. As a teenager Gordon was too young to be called up so he instead became a member of the Auxiliary Fire Brigade and was based at the fire station at Uckfield. Every other week he climbed on board the fire tender and drove to Seaford for a 6 p.m. to 6 a.m. shift. The pumps of the fire engine were attached to the oil pipes either here or in the village. They then had to 'stand by' for the night, should there be an invasion. For most of the time this meant that Gordon got to sleep in the engine. Should the call have come, the fire engines would have pumped the oil into the sea (although how it would be set alight remains unclear).

Today the brick structure, looking a little like a lost bus shelter, remains in place and if you brave the nettles and weeds you can still see the war-time pipelines and valves inside.

The railway line here was the scene of the first ever recorded attack of an English railway

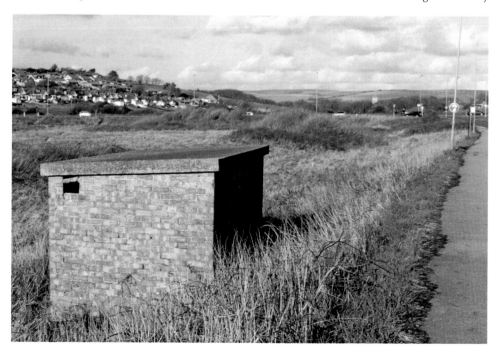

The hut with a secret.

train during the war. On 3 July 1940, a train (the 17:37 from Seaford) was machine-gunned between Bishopstone Station and Tide Mills. The driver, Charles Pattenden of Tunbridge Wells, was killed but the passengers ducked down and tried to hide under the seats. The aircraft then dropped six bombs nearby which shattered the windows of the carriages and injured several passengers. One of them was a Mrs Terrell of Newhaven, who said afterwards:

> It happened so quickly. All the windows were smashed and we had lots of splinters of glass in our hair. My son [Ronald – a babe in arms] had a cut near one eye and the back of my coat was marked as if it had been scorched.

Now walk towards Rookery Hill and Bishopstone where you can see the square tower of the church in the distance. Be careful as you cross the busy road. You can either cut across the fields or walk to Bishopstone via the road.

Just beyond the houses, as you approach Bishopstone, a footpath on the left leads up to Rookery Hill. If you have time this makes a delightful detour. The path, at first shaded by tall trees, climbs up onto open downland. There are ancient burial mounds (tumuli) here marked today by a Victorian trig point. From here there are splendid views across to Newhaven Harbour and inland towards Bishopstone village. The footpath has metal railings along one side which were put up in the 1880s. They are so old that in several places trees have grown around the fencing as if it is being swallowed!

Below left: The hungry trees on Rookery Path.

Below right: Driver Charles Pattenden.

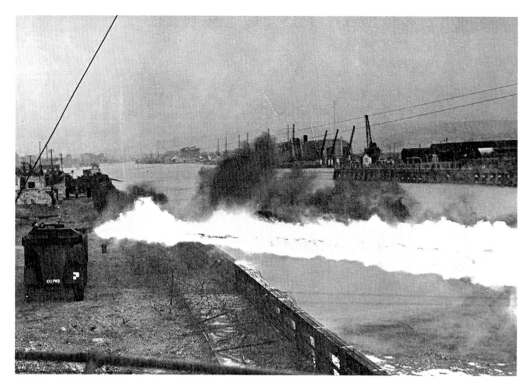

The fire experiment at Newhaven.

Bishopstone Village

As you enter the village the road takes you between Bishopstone Manor House on your right and the site of Bishopstone Place on your left. Bishopstone Place was the seaside home of the Pelham Family (the Dukes of Newcastle) and it was here that their hounds were kept.

Perhaps the most influential member of the family was Thomas Pelham-Holles (1693–1768). He inherited Bishopstone Place from his father in 1712. He celebrated his 21st birthday here and held a ball for over 500 people. He was a supporter of the first Prime Minister, Sir Robert Walpole, and served in his cabinet. His brother, Henry, was MP for Seaford and later served as Prime Minister.

Seaford had returned two Members of Parliament since the thirteenth century but by the eighteenth century only a handful of landowners were entitled to vote. These were under the control and influence of the Pelhams and Seaford became known as a 'pocket' or 'rotten' borough due to the unfairness of its elections.

William Pitt the Elder was the MP for Seaford in 1747. He had previously represented the constituency of Old Sarum (near Salisbury), so is no surprise that Pitt was asked to stand by the Duke of Newcastle. The election was to be held on 29 June 1747 and Pitt stayed the night with the Duke at his country home here at Bishopstone Place. I say 'stayed the night' – the previous day a huge banquet was put on at Bishopstone and all the local gentry (i.e. most of the voters) were invited. The party went on all night and at

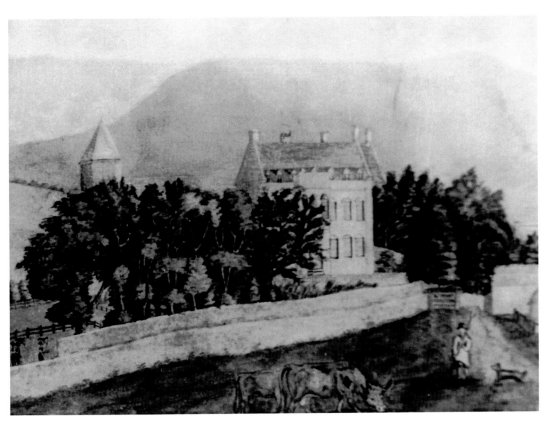

Bishopstone Place.

daybreak the revellers were piled into carriages and taken to the Town Hall at Seaford to vote. They all voted the 'right way' as the Duke himself sat next to the returning officer Charles Harrison as each cast their vote. Pitt was duly elected and went on to serve as Prime Minister. At 24 years, his son, William Pitt the Younger (who was a Freeman of Seaford), was to become the youngest ever Prime Minister in 1783.

DID YOU KNOW?
Winston Churchill and his wife Clementine were frequent visitors to Seaford. Mrs Churchill went to school in the town and was a member of Seaford Golf Club.

Bishopstone Place was demolished in 1830 and the only reminders of the building are the sign on the gate and its wine cellars, which can be seen if you lean over the wall of the adjacent church. These cellars served as the village air-raid shelters during the war.

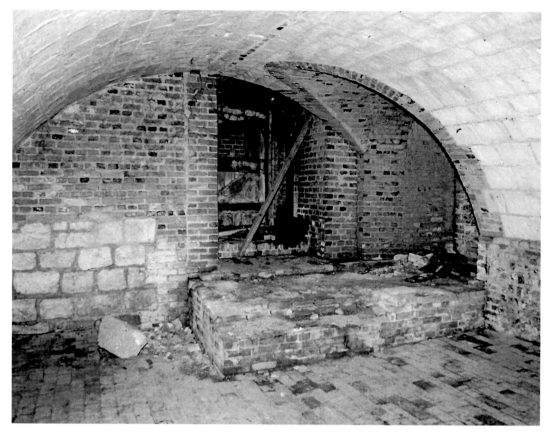

Bishopstone Place cellars.

Bishopstone Manor House, opposite, is still standing but has now been divided into a number of separate residences. High on the wall to the right of the drainpipe you will see the Pelham buckle with the date 1688 and the initials TP (an earlier Thomas Pelham).

A footpath on the left leads through the lychgate to the Saxon church of St Andrew's. To the right of the path are the box-tombs of the Catt family who used to own the nearby Tide Mills.

The church has a sturdy tower and with a good pair of binoculars you should see the carved grotesques around the top. (Some people call them gargoyles but they are not correctly gargoyles unless they have a waterspout.) Although now badly weathered, faces and animals can still be made out. One of these grotesques was a 'sheela-na-gig' – a carving of a woman exposing herself, which was a medieval fertility symbol.

The porch is unusually tall and is believed to have originally been a chapel – possibly for our local Saint who was from Bishopstone. Little is known about the life of Llewenna, a young girl martyred for her faith in the year 690; however, in 1058 her bones were stolen by a thieving Flemish monk called Balgarus. Apparently, she did not want to be stolen as her hand fell out of his red sack so he left it behind. He took the rest of the bones back home where they were revered and many miracles attributed to them until

they were destroyed during the Reformation. The porch has another interesting feature, a Saxon sundial carved with the name EADRIC.

The church is open on Saturdays and is well worth a visit. Among its treasures is a beautifully carved ancient grave slab which is now displayed under the tower. In the north aisle is a large inscribed grave slab reading:

HEARUNDER LYETH THE WIFE OF HENRY DALLINGDEAR – THE DAUGHTER OF ROBERT HANSON – WHO DIED THE 28 OF JANUARY ANO 1639.

Did you notice that something is missing? Parish records show the deceased was called Ann but she was obviously not important enough to be mentioned on her own gravestone!

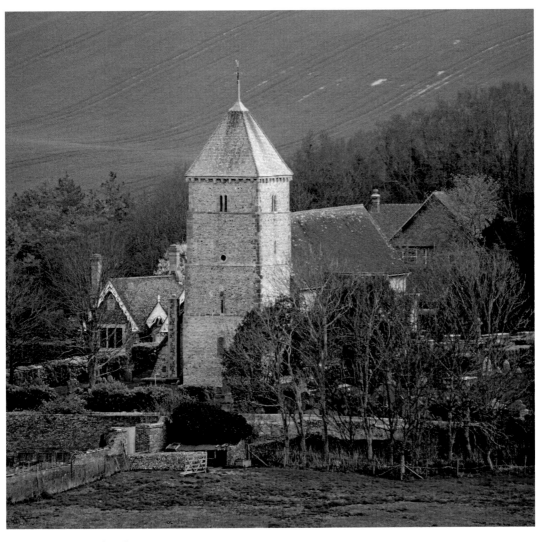

Bishopstone Church.

The ancient Bishopstone
grave slab.

A Clairvoyant and Spy?

The church war memorial gives the names of nine men from the village who were killed in the First World War and four from the Second World War. The memorial also shows the name of Eleanor Standish-Barry, an interesting woman who also used the stage name Nell St John Montague (there cannot be many war memorials which show an alias!).

Nell was born in India and married in Ireland. She was a noted writer and her 1916 play 'An Irish Lead' not only raised money for Irish prisoners-of-war but also became an important means of recruiting Irishmen into the army. Nell directed the play and also took a leading role, but on at least one occasion anti-English feelings caused the performance to be abandoned due to constant heckling.

Nell was an exotic young lady who entertained her after-dinner guests by claiming that she had clairvoyant powers learnt from the Maharajah and mystic fakirs from her early years in India. Her 'abilities' were enhanced when the famous Lord Kitchener attended one of her dinner parties and she predicted that he would meet his death at sea. When he was drowned a few weeks later on HMS *Hampshire* she became a minor celebrity. Two years later Nell's 18-year-old son Charles died while training with the Royal Irish Regiment.

After the war, Nell moved to London where she became a society hostess, clairvoyant and actress, now calling herself Miss St John Montague. She appeared in several films in the 1920s and gave mystic readings to a number of influential people, assisted by her lucky monkey Judy.

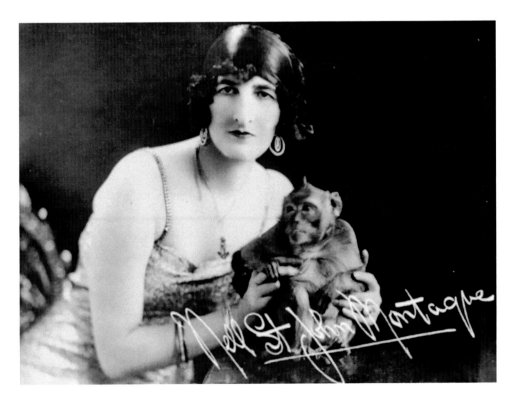

Nell St John Montague with Judy the mystic monkey.

She claimed that her clairvoyant skills had been utilised by such people as George V, the Queen of Spain and even the Metropolitan Police, who had used her mystic abilities to locate the body of Emily Kaye, the victim of the Eastbourne Crumbles Murder of 1924. In fact, she had so many political clients that she was once referred to as 'the Power behind Parliament'. She regularly wrote for newspapers and magazines and in one week in 1927 received over 10,000 letters!

Nell had a grand house in London but spent the summer months at Lulleen, a house on the Esplanade in Seaford, worshipping at St Andrew's Church in Bishopstone. Strangely, she seems to have predicted her own death, saying that she would be killed by a 'fiery streak'. She died when a German doodlebug hit her house in South Kensington. Her body was brought down to Bishopstone and she is buried in the churchyard here.

There was a rumour that she had been a spy. With her connections with India, Ireland, showbusiness, royalty, the military and politicians it is not difficult to understand why. Her memorial service in London was attended by many military officers including Field Marshal Claud Jacob, cabinet minister Sir Harry Verney, and even Wellington Koo, previously the president of the Republic of China. Her possible secret military service may have been the reason why she is included on the war memorial. Spy or not, she certainly went to her grave with plenty of secrets!

More Buckles

Bishopstone village is a quiet collection of old buildings clustered around the church and village green (known locally as the Egg), which comes to life twice a year with a traditional village fête. The village hall (with the ubiquitous Pelham buckle above the door) is at one end of the green and the quaint Victorian almshouses are at the other.

Returning to the road you pass the village pound, once used for stray animals but now a temporary car park. It was here where one of the two massive oil tanks were erected in the Second World War to fuel pipes that were designed to set fire to Seaford Bay. Amateur photography was banned during the war but local artist Mrs Simpson managed to get around the problem by producing a wartime tapestry of the village. This remarkable piece of art was worked between 1947 and 1948 and is the only pictorial record of the secret oil tanks.

We will now walk up Silver Lane between Monksdown and Monksdown Barn, now converted into private homes. Near the lane behind Monksdown is a round metal plate which is actually a template for making cart wheels. A Victorian resident by the apt name of Allwork who lived and worked here would have used this to make the metal bands around wooden cart wheels.

The lane climbs the hill and becomes a rough track and after a few hundred yards doglegs to the right, heading back towards Seaford. The flint wall on your right enclosed land owned by the Pelhams. This is evidenced by a large Pelham buckle set into the wall. This design is usually missed by ramblers who regularly pass by. It is set out in black knapped flint and is about thirty paces to the west of the gateway at the apex of the hill. This is a great place to stop and look at the views across the fields, Seaford Bay and Newhaven Harbour. Nearby a diamond shape has also been set into the wall in flint but its purpose has been lost in the mists of time.

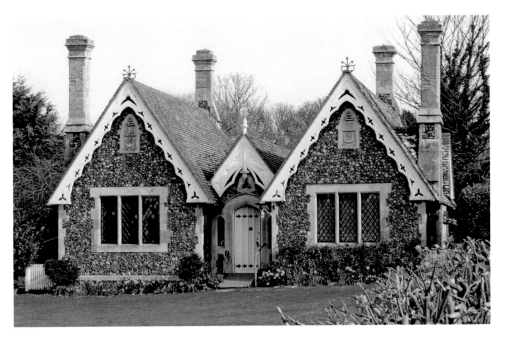

The Bishopstone almshouses.

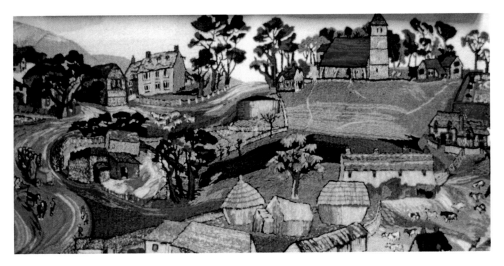

A secret Second World War oil tank shown on a tapestry.

As you continue your walk, the path reaches a small country lane inappropriately named 'Grand Avenue'. There have been various schemes in the past to build housing estates on this land, which is now within the South Downs National Park. Grand Avenue was to be the main thoroughfare with shops and pubs of a modern housing estate, but luckily our forebears realised the importance of the land that surrounded Seaford and these unsuitable schemes were rejected.

The Pelham buckle picked out in flint in Silver Lane.

4. East Blatchington

Turn left at Grand Avenue and just before the road opens out onto a green, take the footpath to the right. This path runs across 'Valley Dip' and up onto Firle Road. You may find it odd that this narrow path is tarmacked. This is because this used to be the main road between Brighton and Eastbourne. Before the building of the Buckle Bypass in 1964, through traffic would pass the seafront but, during high tides and bad weather, it was re-routed inland. Traffic would go up Hillrise and pass along this road (now a footpath) to head towards Eastbourne. In some places you can still see the lines in the centre of the road and when the path reaches Firle Road you can still see the give way road markings.

At Firle Road turn right but be aware that there are no footpaths. After a couple of hundred yards you will see a house on the left called Firle Cottage. You may notice that the front garden looks odd as it seems to be a raised grassy platform. This was the site of an old windmill called the Black Mill. It was first recorded on a map of 1724 but probably built many years before.

This was a post mill, which meant that the whole structure was mounted on a post and could be turned to face the wind. In 1796 the mill was owned by a Mr William Standen, and in 1801 it is recorded that is was capable of supplying three sacks of flour a day.

The former Grand Avenue.

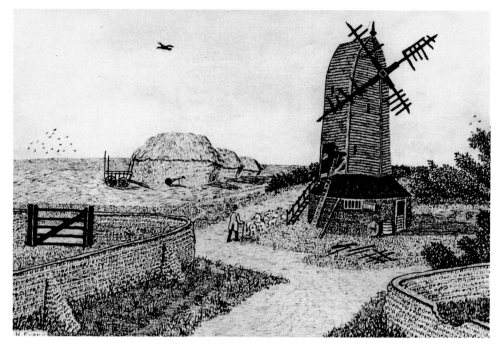

Blatchington's Black Mill.

This seems a small amount for such a large mill and it could be that the owner deliberately misled the authorities, who were creating a 'defence schedule' to supply local troops at the time.

There was a mention of the Black Mill in 1810 when *The Times* ran a story about an old blind horse that had been brought to England as part of the spoils from the Napoleonic Wars. Apparently this old French nag wandered into the path of one of the sweeps and was killed. (In Sussex, the sails of a windmill are called 'sweeps'.)

In 1867 it was recorded that the miller of the Black Mill was a man called Owen Coombs – he was the last owner as shortly afterwards the mill became disused. A drawing by the Seaford artist H. H. Evans shows the mill with broken sweeps and it was eventually demolished in 1878.

On the right of Firle Road is the delightful range of buildings called Alces Place. These appear to be typical old English cottages but in fact this was once a busy working farmyard and the associated fields used to run across the road north of where St Peter's Road is today.

Alce is an old local name and appears across East Sussex. The Seaford branch of the Alce family held land here from the seventeenth century. In 1822, John King purchased the property. In 1818 he had acquired the Manor of East Blatchington, including Blatchington Place.

John King owned much of the land in East Blatchington, including the fields that now incorporate Valley Dip (Princes Drive, Katherine Way, etc.). A row of hedges at the back of Clementine Road still exists and was planted to mark the boundary with Bishopstone.

Alces Place.

This is still known as 'King's Hedge'. King sold the land to the Lambe family, who in turn sold the farm in 1912 to the Seaford West Company. It was then purchased by Richard Bruce Hamilton Ottley, who was an officer in the Army Service Corps in the Great War. It was probably at this time that the building ceased to run as a farm and was used just as a dwelling, while the land to the west called Millers Field became the home of Seaford Cricket Club.

Ottley sold Alces Place to another military man, Commander Wilfred Dunderdale. During the Second World War Dunderdale was the head of British Military Intelligence in France and is credited with helping to obtain a secret Enigma code machine which helped to break enemy radio transmissions.

In August 1956 Commander Dunderdale sold Alces Place and the surrounding land to developers for £8,500. The new owners converted the buildings, including the threshing barn (on the right of the development), into small houses which sold for £3,000 each. Today the wisteria-covered houses of tranquil Alces Place belie the fact that this was once a busy working farm.

Firle Road was once crammed with private schools and there are still one or two schools here. I have been told that there was a large air-raid shelter to accommodate the children nearby, but I have been unable to ascertain its location.

East Blatchington

While walking down Firle Road towards the top of Blatchington Hill a while ago, I noticed a newly rebuilt flint wall on the left. One of the chalk blocks that has been used from the original wall is carved with the initials 'W.I.' Wondering who had carved their initials on the wall I consulted local historian Rodney Castleden, who lives nearby. Rodney had

managed to discover the names of two other sets of initials inscribed into walls in nearby Blatchington Hill. He ascertained that the block was replaced upside down and the initials were actually J.M. This means that the initials probably relate to John Milton, who lived nearby and whose daughter was baptised at the nearby church in 1702.

Turn right at the roundabout into Belgrave Road. If you lean over the churchyard wall about half way along you will find a gravestone decorated with crossed flintlock pistols and a large cutlass. This is the grave of Stephen Rabbit, a private of the 11th Regiment of Light Dragoons. He died in May 1804 aged just 23 years. A few years ago the Seaford Monumental Inscriptions Group revealed the cautionary wording on this grave with the help of the beam of a powerful torch:

> ALL THAT COME MY GRAVE TO SEE, AS I AM NOW, SO YOU MUST BE, DEPART FROM SIN – LIVE GODLY, SO WELCOME DEATH COME!

I have already mentioned that the Parish of East Blatchington included a large battery which by 1761 was ready to receive contingents of troops from all over the United Kingdom. This is evidenced by the number of the men and their families who were buried within St Peter's Church. Take the Loyal Lincoln Volunteers (also known as the 81st Regiment of Foot) – they stayed at Blatchington Barracks from December 1809 to April 1810. During this five-month period, eleven of the soldiers died.

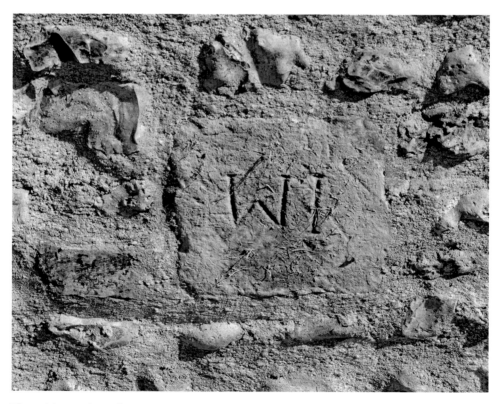

The writing on the wall.

Depart from Sin!

In all, 120 people from the barracks are buried at the church, most with no stone to mark their last resting place; however, three gravestones survive. Close to the north wall of the church is the grave of John Dymond, a Sergeant Major in the 2nd Somerset Militia who died aged 48 years in May 1807. His grave also has a gloomy epitaph:

A SOLDIER LIES HERE, DEATH'S VICTIM – FOOD FOR WORMS, FLESH
MUST RETURN TO DUST AND THE HEART MUST CEASE ITS BEATING.
READER REMEMBER THIS!
As a last tribute of respect, this stone is erected by the non-commissioned officers
of the regiment.

The grave is decorated with carved flowers and flags and a winged cherub's head. John Dymond must have been a well-loved and respected member of the regiment to have had such a headstone.

Lastly, hidden amongst the undergrowth to the south of the church is the grave of Elizabeth Ward, whose husband William was a Sergeant in the Derby Regiment. She died in March 1799 aged 47 years and her gravestone is decorated by a skull set in front of a large bone and crossed trumpets. One wonders why she had the honour of being buried with a permanent tombstone? Was she the regimental cook or maybe a mother figure, sewing buttons onto the uniforms of young officers? Did she attend services here, worshipping with the local agricultural community and other villagers, maybe joining the parishioners afterwards for a drink and a chat? Did she miss her home or was she used to travelling from place to place with her husband? The secrets of this military wife have been taken to the grave.

Non-military memorials in the churchyard include that of Dr William Tyler-Smith (1815–1873) who founded the Seaford Improvement Committee and who did much to enhance the town in the late 1800s, including building Pelham Terrace (next to Morrisons) and bringing the railway to Seaford in 1864.

Thomas Guthrie (1856–1934) is also buried in the churchyard. He was on the staff of *Punch* magazine and was also an author. His most famous work was *Vice Versa*, the story

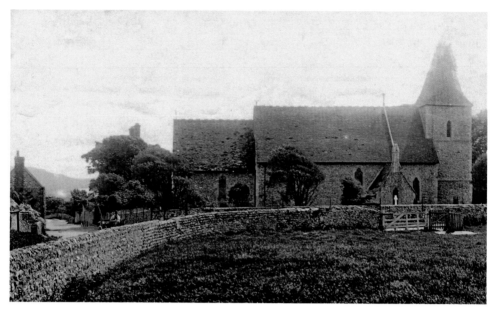

St Peter's Church, East Blatchington.

of a young boy who has troubles at school. His father rashly tells him that his schooldays were the best in his life and he wishes he could have them again. Due to a magic stone the two swap bodies and the father has to go back to school while his son runs the family business. This story has been adapted for film on several occasions, the most recent being in 2003 as *Freaky Friday* starring Jamie Lee Curtis.

The church dates back to twelfth century, with thick walls cut through with lancet windows. The flint tower at the west end has a broach spire (an octagonal spire on top of a square tower). The tower is thirteenth century, although there is debate as to whether there was an earlier central tower like that at Iford Church, just south of Lewes. A chapel or aisle may have been built onto the southern side of the building as two stone arches can still be seen from the outside near the present porch.

Over the years there have been many changes to the church, particularly around 1860 when the renowned Manx architect Ewan Christian (1814–1895) removed the old pews, added the vestry on the north side and rebuilt the porch. (Around the same time he also restored Selmeston Church.) This work was sponsored by the Dennis family, the Revd Robert Dennis having served at the church from 1844 to 1880.

Dennis was a naturalist and, like Gilbert White (1720–1793) and Charles Darwin (1809–1882), was fascinated by the way that nature worked. He was very much a bird enthusiast and wanted to know more about how they lived, what they ate and how they bred. Indeed, Dennis used a book by White as a reference.

Nowadays we would go about this task armed with a pair of binoculars and camera, but these luxuries were not available in Victorian Seaford. So how do you get close enough to a wild bird to examine it? Simple – you buy a gun and shoot it! The pages of Dennis's diaries are littered with details of the birds he shot.

St Peter's Church today.

The Reverend Dennis.

After he shot a specimen, the bird was often taken over to Brighton, where a local taxidermist George Swaysland of Queen's Road, would stuff it.

When he was younger, Dennis would take long walks over the South Downs, often accompanied by his friend Mr Bedford, the rector of St Leonard's Church, Denton and his faithful gundog Dick. They would spot and bag a variety of birds. Seaford, of course, is a marvellous place for birdwatching as there are a variety of natural habitats within a few miles; from the chalk cliffs of Seaford Head to the fresh water of the Cuckmere, the salt water marshes around the Tide Mills area and the grassy inland downs. Dennis lists hundreds of birds seen in Seaford. Many of them are still to be seen, but others are rare today such as Golden Oriels, Ospreys and Cirl buntings.

DID YOU KNOW?
In 1860 some men were looking for eggs on the cliffs near Seaford when they saw something shining amongst a jackdaw's rough nest. It was a brass collar engraved 'Mrs Phillips'. It was found to be the property of Lieutenant Frederick Philips RN but it didn't belong to his wife – Mrs Philips was his pet cat!

As his interest became widely known, people would often bring specimens to him and his diaries give an interesting glimpse into life in East Blatchington and the people who lived there. One thing lacking from the diaries are details of his clerical work within the parish – he seems to be far more interested in feathered flocks than his own congregation. When he does mention his parishioners – Woodham the brewer's son, Charley Lymphs, Banks the bricklayer and John Ancell the Newhaven coastguardsman – it was because they brought birds to him.

A list inside the church shows that the first rector was Hamo de Warenne, who served from 1257. Another was Edward Wilson who, along with William Snatt of nearby St Leonard's Church, was a non-juror, which meant that these Seaford clergymen refused to swear an allegiance to King William after the Catholic King James II was deposed. As a result, Wilson was deprived of his appointment. The Revd Henry Lushington was vicar from 1734 until 1742, when he became vicar of St Mary's in Eastbourne. He was responsible for building the Manor House there, which was later to become the Towner Art Gallery.

The interior of the church is bright, airy and often lit with colour from the tower window, which was installed in 2004 by the Reigate-based artist Jane Campbell. Memorials inside include one to Henry Coxwell, a balloonist who once held the world altitude record and who made hot air balloons from his factory in Richmond Road, Seaford.

As you leave the church notice that a millstone has been set into the path near the porch – maybe this came from the nearby Black Mill?

Leave the church and turn left into Belgrave Road, noting the plaque on the wall nearby to show that the church hall was once the chapel of Blatchington School that stood nearby.

The pioneering Henry Coxwell.

Miniature and Model Trains

Opposite the tennis courts, on the corner of Belgrave Road and Kingsmead, is a house containing a miniature railway in the garden. The East Blatchington Branch Line is open for just a few days a year (details can be obtained from the Tourist Information Office) to raise funds for charity.

Kingsmead is named after the school which stood on this site until September 1968. The school was built in 1914 and included a tuck shop, swimming pool, two cricket pavilions, tennis courts, model yacht sailing pond, roller-skating rink, rifle range, sandpit, gardens and a model train room, all set in 10 acres of land. The school could accommodate eighty boys and among the 'old boys' were champion showjumper Harry Llewellyn, Geoffrey Keyes VC, and even two kings. These were Prince Ronald Mutebi, who is now the Kabaka (Tribal King) of Buganda, Uganda, and Prince Maha Vajiralongkorn, who became the King of Thailand in 2016.

DID YOU KNOW?

Among the pupils of St Peter's School, which once stood off the Alfriston Road, was Anthony Blunt, the Queen's Art Historian who was exposed as a communist spy, and Donald Campbell, the world speed hero who died when his boat *Bluebird* crashed on Lake Coniston in 1967.

On the corner of Carlton Road is a pillar box with the cypher of George VI. It was hit by a vehicle in 2010 but luckily the lower portion survived. This is the part which is of interest as it has an Ordnance Survey bench mark carved into the brickwork.

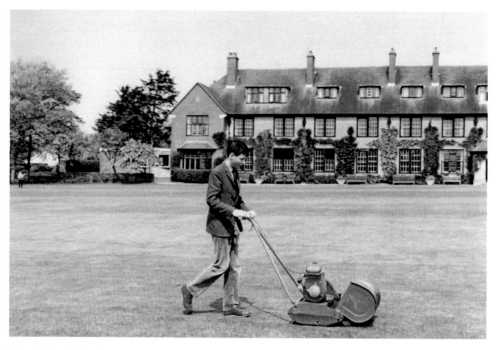

King's Mead School.

The pillar-box benchmark.

Wartime Past Revealed

Benchmarks were made to assist the Ordnance Survey in making their maps. There are 190 'fundamental benchmarks' in the country but there are about 500,000 'lower order' benchmarks which take the form of an upward-facing arrow with a line above it. They are placed on permanent structures such as church towers (did you notice the one at Blatchington Church?) and the height above sea level for each is known.

Turn right into Carlton Road and take the second road on the right called King's Mead Lane. This is narrow and easy to miss but is worth a look as it is the location of one of Seaford's little-known secrets and probably one of the least visited war memorials in the country. The memorial remembers the boys of the nearby King's Mead School who lost their lives in the Second World War.

Many of the King's Mead boys joined the services and, as this was a school for the privileged classes, they gained commissions. They fought in most theatres of war, in all three services, and many of them were decorated for bravery. Geoffrey Keyes was posthumously awarded the Victoria Cross for his attack in 1941 on a secret German headquarters building 250 miles behind enemy lines in Libya. It was mistakenly thought that Rommel, the head of the Afrika Korps, was in the building at the time.

Forty other King's Mead old boys also lost their lives in the war and all are listed on the memorial. All are ranking officers including a Lieutenant-Colonel, three Majors, eight Captains and eight Lieutenants. Thirteen of the names on the memorial served in the RAF including John Tinne, who was the Squadron Leader of 70 Squadron and was also killed in Africa.

Another of the names listed is Hugh Trenchard, the son of 1st Viscount Trenchard, a former Commissioner of the Metropolitan Police and the Marshall of the RAF during the war.

When the school closed it became a nursing home, but in 2003 it was demolished to make way for a development by Barratt Homes. The building company, realising the importance of the schools Roll of Honour, donated a small area as a permanent memorial to the old boys killed in the war. This takes the form of a smart 2-metre high granite obelisk standing on the site of what was previously the school swimming pool. The following words appear on the memorial: 'In grateful memory of King's Mead School which stood near this site from 1914 to 1968 and especially of those former pupils of the school who gave their lives in the service of their country'. The names inscribed on the memorial were previously carved into the windows of the school chapel.

The memorial was formally unveiled at a ceremony on 22 May 2004, attended by several old boys including Andrew Bowden, the former Brighton MP, and the Revd Francis Gardom who led the service. David Maxwell and Ann Hubbard, who had campaigned for the memorial garden, also attended, as did Lord Roger Keyes, who was the brother of Geoffrey Keyes VC. Prior to his death in 2005, I met Lord Keyes on a couple of occasions and he was a really pleasant chap. His father (also Roger) was the hero of the Zeebrugge Raid of 1918. It was at this raid that my grandfather, Alec Gordon, a Royal Marine, was seriously injured. My father was named Roger after Lord Keyes.

Return to Carlton Road and walk up to the junction of Beacon Road. During the Second World War there was a row of four large guns nearby facing the sea. Between 1943 and

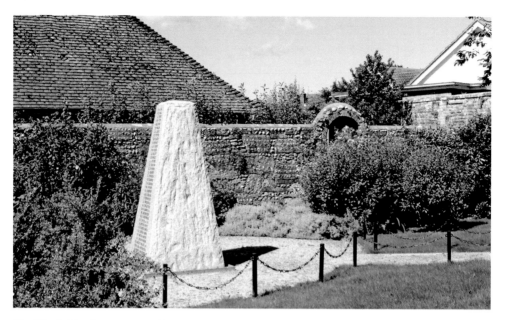

The King's Mead war memorial.

Geoffrey Keyes while at King's Mead.

1944 this area was the home of B troop of 583 Heavy Anti-Aircraft Battery of the Royal Artillery. The guns were 3.7 inch anti-aircraft (ack-ack) guns mounted on cement bases.

The gunners were based in Nissan huts at the north end of Beacon Road. The officers were based in a house opposite (now expanded to be the Three Ways nursing home.)

A company of girls from the ATS (Auxiliary Territorial Service) was based in houses in nearby Westdown Road. It was their job to work as 'predictors' and 'spotters'. They worked from temporary buildings and caravans on land which is now occupied by Beacon Drive; however, the plotting table and communications centre was sited underground.

There is no evidence of this gun emplacement today other than photos of five of the ATS girls in Westdown Road, although I do have in my possession a drawing of a similar gun which was based at nearby Bishopstone.

After the war, this area was developed and houses built, but one of the first occupants, at No.33 Carlton Road, was a man who held one of the most important wartime secrets. His name was James Stagg. Stagg was born in Scotland in 1900 and was a member of the British Meteorological Office, but during the war held the rank of Group Captain. He was the chief meteorologist for SHAEF (Supreme HQ Allied Expeditionary Force) and therefore the weather forecaster for Operation Overlord, the D-Day landings. He managed to persuade General Eisenhower to delay the secret invasion until 6 June 1944.

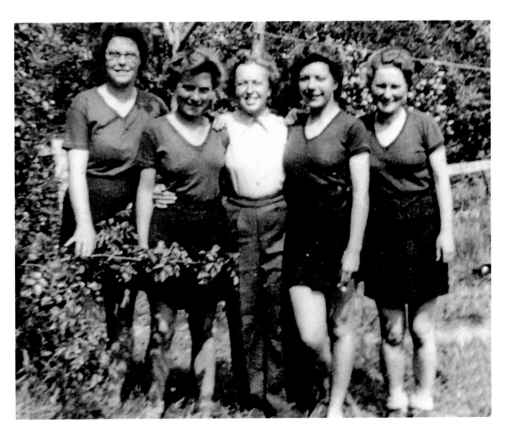

The ATS Spotter girls at Seaford.

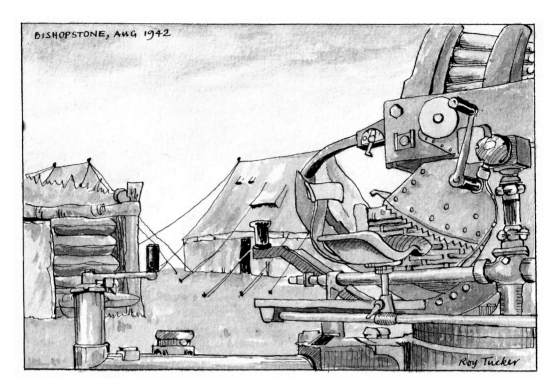

BISHOPSTONE, AUG 1942

Roy Tucker

An anti-aircraft gun at Bishopstone.

Stagg provided what has been described as the most important weather forecast of all time. Had the time of the invasion been earlier, storms and heavy winds would have put the whole operation in jeopardy and probably cost the lives of thousands of Allied servicemen. He was later thanked by Eisenhower and was appointed an Officer of the US Legion of Merit, and made a Companion of the Order of the Bath.

5. The Town Centre

Church Street

We will start our tour of the town centre in Church Street. The street has two Ordnance Survey benchmarks, one is very weather-worn and is on the side of the church. The other is a metal 'flush plate' and is on the pillar of the Old School Surgery. You can clearly see the holes where the surveyor's bench would have been attached. Benchmarks of this type are located every mile and the next ones are sited on the trig points at Rookery Hill and on High & Over.

The school on your right (now the surgery) was designed in two halves – one side for boys and the other for girls. A part of the building is now occupied by a children's nursery but I suspect many of the parents who use the low brick-built structure do not realise that it was formerly a Second World War bomb shelter designed to protect Seaford children during the air raids. Unusually, the names of the civilian victims of the air raids are listed on the war memorial in Sutton Park Road.

DID YOU KNOW?

Seaford's war memorial in Sutton Park Road was installed on an area of land known as the 'Cat's Cemetery'. It is unusual in that it lists the names of civilians killed during the many air raids of the Second World War. It is also the site of a paving slab commemorating Cuthbert Bromley, who was awarded the Victoria Cross during the Gallipoli Campaign of the First World War.

The Victorian church wall opposite the Post Office holds a secret – actually two. Apparently, the builder was a Yorkshireman and incorporated a number of white stone Yorkshire roses into the design. There were once a dozen of them but frost has taken its toll and today only two remain. See if you can spot them.

Before we cross the road and go into the churchyard look in the door of the Post Office, as it contains a reminder of Seaford's medieval past. In 1976 I had ideas of becoming an archaeologist and joined the Sussex Archaeological Field Unit in their excavation of the land here before the Post Office was built. I remember digging in the heat of a hot summer and the pits and wells that we excavated. (I also remember having my first pint of Harvey's delicious beer in The Plough opposite.) One of the finds was the jug that is on display in the Post Office entrance. It was found at the bottom of a well and dates from the late 1200s when Seaford was a busy port. The jug was made locally, probably in Piddinghoe or Ringmer.

A map-making benchmark.

A hidden Yorkshire Rose.

The Church

Enter the churchyard via the Victorian lychgate. St Leonard's Church has stood in the centre of Seaford since shortly after the Norman Conquest. It was so well used that within a few years it had to be extended with the building of two aisles. The church was modernised in the 1200s and the old-fashioned rounded Norman arches were replaced by early English pointed ones. There is evidence of this inside but one of the old, heavily restored Norman arches can be seen on the south side of the church.

I have mentioned that Seaford was 'at its height' in the thirteenth century. In 1298 the town returned its first two Members of Parliament, William Hobey and Geoffrey Cuckoo (they attended Parliament in York). Three years later, in 1301, Edward I granted the right for Seaford to hold an Annual Fair and in 1302 Seaford was able to send an armed ship north to fight the troublesome Scots. In 1336 we doubled our commitment to two ships and in 1338 a captured French ship was actually brought into the port. This prosperity and early successes against the French were short-lived.

Unlike the East Sussex ports of Winchelsea, Rye and Pevensey, Seaford was never fortified; it had no town walls, no castle and no defensive towers. It must have been an easy target for raiders. In 1341 Seaford is described as being 'damaged often by the assaults of the French with inhabitants wounded or slain'. Seaford increased its strength to five ships and eighty men (this must have been the majority of able-bodied men in the town) but to no avail.

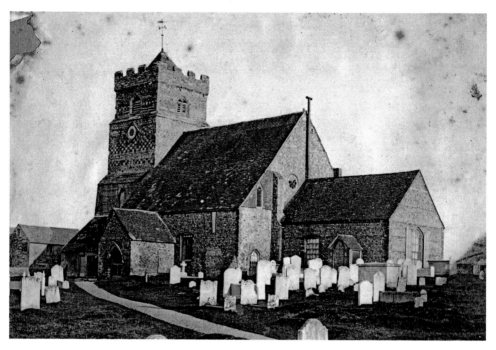

St Leonard's Church prior to 1870.

The Black Death first struck in 1348 and by 1357 it was reported that:

> The Town of Seaford has been for the most part burnt down and further devastated by pestilence and the calamities of war so that the townsmen have become so few that they can neither bear their burdens nor undertake the defence of the town.

It was at this time that the church was burnt down during a French raid and for many years thereafter stood derelict.

In 1376 the Archbishop of Canterbury sponsored Seaford's new priest, Walter Estoune. Three years later, in 1379, French ships actually sailed through Seaford Harbour and up the Ouse towards Lewes – the weary population must have been terrified. One wonders if Father Estoune gathered them together in the church to provide shelter. Things were bad – the triple whammy of the fever, the French and floods were so unrelenting that in 1380 the few surviving residents petitioned Richard II for remission of their taxes.

Slowly the fortunes of Seaford changed: on 25 October 1415 the English beat the French at the Battle of Agincourt and despite the cold winters (the Thames froze over in 1434) things gradually improved. Seaford even got royal recognition when, in 1461, Edward IV gave the Manor of Seaford to his Queen, Elizabeth Woodville.

The Church is Rebuilt

Richard Hoose became the vicar of St Leonard's in 1478 and it was under his direction that Seaford Church was rebuilt. Building material gathered from the wreckage of the old church, and presumably other ruined buildings, was used to build a new south wall, porch

and tower. Look again at the walls built at this time and you can see that they contain a variety of building material including flint, greensand (probably obtained from a quarry near Eastbourne) and lumps of Caen stone. These blocks would have been brought from France as ballast in ships and dumped near the harbour when they docked at Seaford.

When the church was rebuilt a number of 'consecration crosses' were included in the walls and some of these can be seen, picked out in flint, under the clock on three sides of the tower.

Like Bishopstone Church, grotesque corbels were placed under the eaves of the roof. Two of them have been rescued and are on display inside the church but one is still in place on the east side of the tower. It takes the form of a sheep's head and probably represents the main export from the port of Seaford – wool.

As you enter the church look at the top of the first column. This is a 'historied' column with medieval biblical carvings – some of the oldest art to be seen in Sussex. The biblical scenes would have been used by early priests to illustrate their sermons. The carvings depict Adam and Eve, Daniel being thrown into the lion's den, the Massacre of the Innocents (with King Herold on a throne), the Nativity and the baptism of Christ.

The best preserved scene is the Crucifixion; the haloed figure of Christ is shown; the nails in his hands and feet clearly depicted, as are his wounds. On the left is the Virgin Mary, her right hand cupping her left elbow as she holds her head in anguish. On the right is the figure of St John holding a Bible.

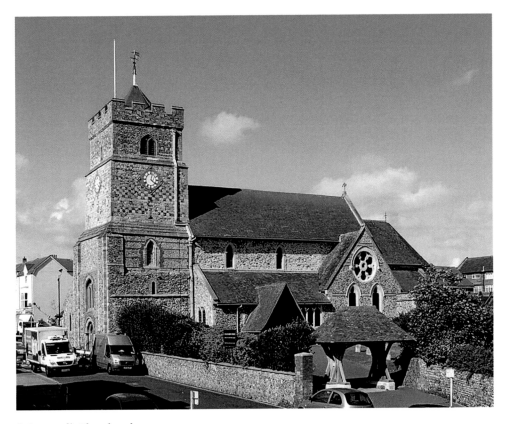

St Leonard's Church today.

A medieval consecration cross.

A nearby stained-glass window was erected in 1901 and designed by Charles Eamer Kempe (1837–1907), who was a Sussex artist. He was responsible for many stained-glass windows across the country but particularly in the South East. He signed his work by including a small wheatsheaf in the design and this can be seen on the bottom left corner of the window. The window shows the three saints associated with the church: St Leonard

A reminder of Seaford's former export trade.

on the left was the patron saint of prisoners, which includes 'Sailors in Bondage', meaning that he was revered by sailors who had been press-ganged into service. These sailors would visit the church when they stopped off at the port of Seaford. St Leonard is depicted holding a heavy ball-and-chain to represent the prisoners he helped. The window also shows St Wilfrid in the centre and St Pancras on the right.

There are five windows at the east end of the church above the altar. The window on the left is dedicated to Felton Mathew, a man who founded a capital city on the other side of the world. Felton was an architect and surveyor and in 1829 found himself in New South Wales as an assistant surveyor for roads and bridges. He corresponded with his cousin Sarah who lived in Clinton Place, Seaford and in 1832 she travelled to Australia, where they were married. During the 1830s Felton, accompanied by his wife, explored and surveyed much of the outback but in 1840 they sailed to New Zealand, where he had been tasked to determine the site of a capital city for the new country. Felton brokered the purchase of land from the Maoris which became known as the Waitangi Treaty and

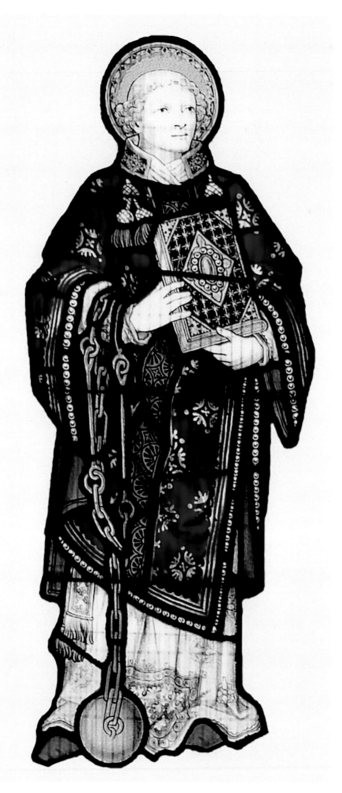

St Leonard with his ball
and chain.

set about drawing town plans, which were to be the basis of the embryonic city. Mr and Mrs Mathew remained in Auckland for several years but Felton became embroiled in a dispute with the New Zealand Governor, who he believed had overlooked him for promotion. The couple decided to return to Seaford but Felton died en route home. Sarah continued to live in their house in Seaford and commemorated her husband with the window seen at St Leonard's Church.

There are several brass plaques in the north aisle but of particular interest is one for Dr William Pringle Morgan. He was a doctor in Seaford for over forty years, particularly taking care of the many schoolchildren in the town. He lived in a house called Rostrevor (now the site of Tesco) and worked from a surgery in Hurdis House, Broad Street.

Pringle Morgan was the doctor for a young boy called Percy who, although clever and active, found great difficulty in reading and writing. The doctor realised that the condition was nothing to do with the mental ability of the boy but rather a problem with visual perception. He wrote up his findings, which he first described as 'congenital word blindness', which were published in the *British Medical Journal* of 1896. Today this Seaford doctor is recognised throughout the world as the person who first identified dyslexia. Incidentally, Pringle Morgan was in Namur in Belgium in 1914. He was on a 'fact-finding' mission with the Duchess of Sutherland and a group of Red Cross nurses when the town was subject of a bombardment prior to the German invasion. He was therefore probably the first English doctor to treat victims of what was to become the First World War.

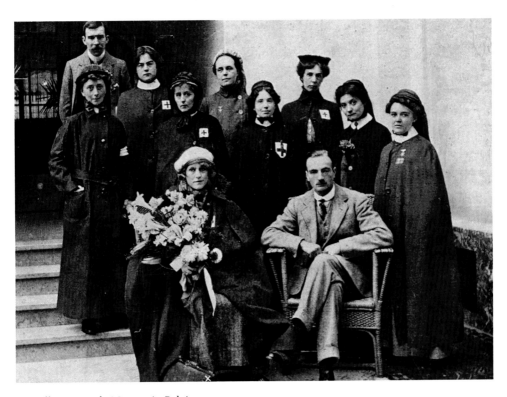

Dr William Pringle Morgan in Belgium, 1914.

Further along the wall is a brass memorial to Cuthbert Bromley, who was another victim of the First World War. He was the son of Sir John Bromley and lived at Sutton Corner, a house near to where the war memorial now stands. He was a major in the Lancashire Fusiliers and was involved in the fateful Gallipoli landings of April 1915. Despite the horrendous fire from enemy positions, Bromley managed to get his troops ashore, capturing the beach and nearby cliffs. For his actions he was awarded the Victoria Cross. Unfortunately, he was killed later in the year when the ship he was travelling on was torpedoed in the Mediterranean. Bromley Road in Seaford is named after him and in 2015 an incised paving stone was placed at the war memorial to remember his bravery.

DID YOU KNOW?
Seaford cemetery is home to one of the largest numbers of war graves in the south of England. There are nearly 300 servicemen buried here, the youngest being a sixteen-year-old Canadian soldier and the oldest a sixty-nine-year-old captain in the Merchant Navy. Here are graves for soldiers from all over the world, including the West Indies, Canada and America.

The Bromley memorial at the Seaford war memorial.

Under the tower are several memorials, including that of navy captain James Walker who saw action at the Battles of Camperdown (1797) and Copenhagen (1801), where he served under Nelson. Unusually, his memorial includes an exclamation mark!

If you look very carefully between the memorials on the north wall you will notice that graffiti has been scratched into the stonework, mostly dating from the eighteenth century. The origin of this graffiti has been a mystery for many years but I think that I have established who was responsible. A newspaper dated 27 February 1746 reads:

LEWES: Sussex Feb 23rd – On Saturday, the Sky, a French Privateer, fell in with the Furnace Bomb, a 20 gun-ship off Seaford about Eleven o'Clock in the morning and was taken about Five in the afternoon after a short engagement. The said privateer had on board 62 men, besides officers which are present confined in Seaford Church and the officers are kept on board. She has used this coast for some time as a smuggling Cutter and so made prey of everything she could lay hands on. The captain is Swiss.

Who knew that the landlocked Swiss had pirate ships? A short report in another newspaper reads: 'The Captain of a Swiss Privateer was taken by one of our men-of-war last Saturday. The ship was sent to Newhaven and the men confined in Seaford steeple.'

Church grafitti scratched by pirates.

These reports clearly show that the tower of St Leonard's Church had a previously unknown use – that of a prison. And who would have enough time on their hands to deeply scratch their initials into the wall of the tower? Prisoners, of course. I am not sure, however, that St Leonard, the patron saint of prisoners, would have approved!

DID YOU KNOW?

On 3 May 1808, the 53rd Regiment of Foot were on patrol at Crowlink Gap near Friston when they caught a gang of smugglers laden with contraband spirits. After a considerable fight the troops seized five horses and twelve casks of foreign spirits, which they took to the Newhaven Customs House. They also arrested two men who were taken before the magistrate, Thomas Henry Harben of Corsica Hall, Seaford. During the skirmish two smugglers were seriously wounded and a soldier later died – not from his wounds but by drinking 'an inordinate amount of seized liquor'!

Seaford Cowards?

We leave the churchyard via Place Lane (once called North Street) and cross the busy Broad Street into Sutton Road. Just past the bakery there is a council car park. This was formerly the site of the Empire Cinema.

The Empire was the second Seaford cinema (the first was in Brooklyn Road). It was opened on 10 May 1913 and could seat 500 people on two levels, which was a lot when you bear in mind Seaford only had a population of 4,000 then.

The box office, at the top of six broad steps, was open daily. Mr Simmons was the uniformed commissionaire who would welcome you with a salute and call young Harry Briggs, who was employed as a pageboy, to usher you to your seat. There were usually two films per showing. These were accompanied by newsreels and a cartoon or a short comedy, such as Laurel and Hardy.

In January 1915, the first colour film was shown – Pathe's *Curse of War*. The Empire Cinema produced a weekly booklet, 'The Empirecho', giving details of the films. It had adverts and there was also a monthly competition to win a free cinema ticket.

The Empire Cinema provided Seaford with entertainment during the difficult days of the Great War, when thousands of soldiers 'went to the pictures'. A cinema later opened in the South Camp. Due to its popularity, the Empire Cinema also held concerts and plays.

The end came on the night of 28 February 1939, when a fire ripped through the building. There were two features that night, *The Port of Seven Seas* starring Wallace Beery and *Walking Down Broadway*. After the first film, a Gaumont British newsreel was shown before being taken along to the Ritz cinema in Dane Road to be shown again. After the second film, the customers left, the main electric switch near the front doors was turned off, and the premises locked. One of the usherettes, Miss Coffen, walked the short distance to her home in Croft Terrace.

Above: The Empire Cinema (on the right).

Right: Harry Briggs at the
Empire Cinema.

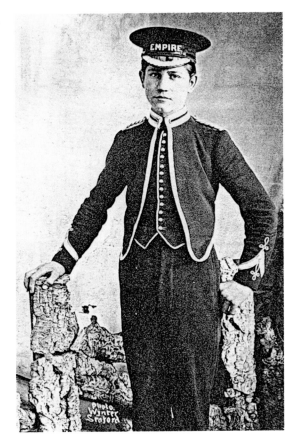

All seemed quiet, but a fire had started in the boiler room under the main stage and slowly took hold. Miss Coffen was woken by her mother just before 2 a.m. and told that the cinema was alight. She ran to a nearby telephone kiosk and raised the alarm. The fire brigade were quick to react and maroons were sent up from the Esplanade, which woke many Seaford residents and bathed the town in a vivid red glow. The fire engine was on the scene in eight minutes but Chief Officer Reeves soon realised that the assistance of the Newhaven brigade was needed and they in turn arrived shortly afterwards.

Forty-two-year-old Fred Mace had joined the fire brigade twenty years earlier and attended the fire with his brother Charles of Stafford Road, who had joined two years before. Shortly after 3 a.m. Fred climbed a 40ft (12m) fire escape ladder to direct a hose onto the burning roof (roughly where the telegraph pole is today). There was a high wind blowing and it became necessary for some men to hold the base of the escape ladder in an attempt to stop it swaying. This proved impossible and the ladder crashed to the ground, seriously injuring Fred, who died at the Sussex County Hospital in Brighton a few hours later. Charles had to break the sad news to their mother, who was still mourning after another of her six sons, Joe, had been killed in the Great War. Fred's life had been insured by Seaford Council for just £250; he left a widow and two children.

The local press reported the fire but also mentioned that the Seaford crowd had failed to assist the fire brigade in steadying the fire escape. It was reported that on two occasions the police had asked the crowd to help but only three men had volunteered.

An inquest was soon opened by Dr Hoare, the coroner for East Sussex, who called Fireman Mace a hero. The jury heard evidence relating to the escape apparatus which was old, wooden and had no guy ropes to secure it. However, returning a verdict of accidental death, the coroner criticized the alleged apathy of the crowd by saying, 'I am not happy as to the conduct of the crowd. There does seem to have been some lack of enthusiasm to come forward to help in manning the wheels of the escape.'

The story was picked up by the *Daily Mirror*, who accused Seafordians of cowardice. I recall former Seaford historian, the late Pat Berry, telling me that she had heard that at a football match a short time later the Seaford supporters were taunted by cries of 'Cowards! Cowards!' Seaford hung its head in shame.

But were the complaints justified? In 2006 I spoke to someone who was in the crowd at the time of the fire – Percy Thompson; he was also one of the last people to have lived at Tide Mills. I asked Percy about the fire but he did not recall anyone asking him to help and I am sure an active young military man like Percy would have been keen to assist.

The criticism must have irked the town because a few weeks later a mass meeting was held at the Queens Hall and over 700 people attended. The chairman, Sir Alfred Cope KCB, was supported by the vicar of Seaford, the Revd Charles Maxwell, and the Roman Catholic Priest Father Webb.

Sir Cope had been a secretary to Prime Minister Lloyd George and was also the only British politician who was trusted by Sinn Féin in the early 1920s; he had almost single-handedly secretly negotiated the independence of Eire.

Sir Cope had been busy and had interviewed many witnesses to the cinema fire, including the Chief Constable, the Fire Chief and even the coroner. Many witnesses came forward to say that there had been no requests for assistance and indeed the police had

tried to keep people away from the fire escape ladder. Among the witnesses to the fire were Mr Carter and Mr Pettit, both former firemen. They told the meeting that they had volunteered to assist but had been declined. Other witnesses, mostly ex-servicemen, told a similar story and forty other witnesses had felt so strongly that they had already written to Seaford Council to say that they had heard no request for help.

The Revd Maxwell gave a rousing speech saying that he had travelled all over England but had never met a better set of men than those he had met at Seaford. He called the *Daily Mirror* headlines 'unwarranted, unworthy, unjustified and contrary to the facts'. Father Webb then asked for practical help in contributing to the fund for Fireman Mace's widow.

The meeting unanimously agreed that the death of Fred Mace was not attributable to any lack of volunteers or of any 'holding back' by the public present. The meeting ended with requests for more Air Raid Precaution and St John Ambulance volunteers, followed by the National Anthem.

A few weeks after this sad incident the country was plunged into war, which resulted in the names of many more brave Seaford men being added to the war memorial, proving that the people of Seaford were not cowards. The cinema site was not built on and during the war a huge emergency water tank was erected here, the evidence of this could be seen until about fifteen years ago, when the car park was resurfaced.

In February 2010, a memorial plaque was unveiled by local MP Norman Baker and later that year the name of Fireman Fred Mace was added to the National Fire Brigade memorial near St Paul's Cathedral.

DID YOU KNOW?

In 2012 two local men, Don Mabey and Laurie Holland, were given the Freedom of Seaford; they were the first men to receive this accolade since the 1801.

Walk through the car park along the short Sutton Croft Lane into Croft Lane and turn left. On the right you will see the impressive Fitzgerald Almshouses with their mock-Tudor chimneys.

A Secret Safe

The foundation stone of the almshouses was laid by John Purcell Fitzgerald in 1864. Fitzgerald was Seaford's last Member of Parliament, serving the town between 1826 and 1832, the date of disenfranchisement. He clearly loved the town and lived at Corsica Hall, which we encountered earlier.

The almshouses are of red brick and, so that everyone was aware of who was responsible for this generous donation, the Fitzgerald coat of arms were placed not once but twice facing the road. These can still be seen, although they are getting a little weathered.

The arms show a diagonal saltire (cross) surmounted by a monkey and a hand holding a sword. The monkey was part of the Fitzgerald coat-of-arms and is rarely seen in heraldry.

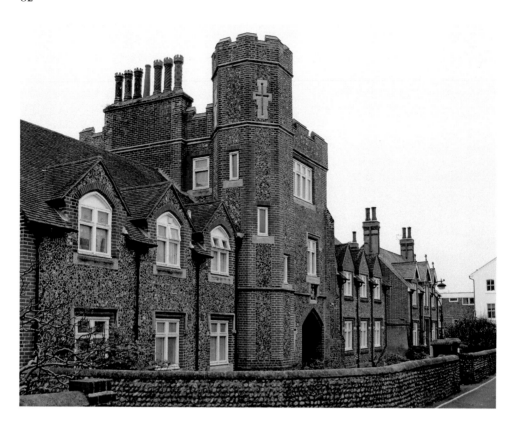

Above: The Fitzgerald almshouses.

Left: John Purcell Fitzgerald.

It is said that the monkey was a family pet who once warned the family of a fire in their house. The hand carrying the sword is from the Purcell coat-of-arms. On either side of the shield you can still make out the Fitzgerald family motto *Crom Aboo*. Crom was an ancient Irish fortress once owned by the family and 'Aboo' was their battle cry.

Although luxurious in their day, the basic facilities (including just one bath) remained until 1964 when the building was renovated. Each of the units now has a fitted kitchen and bathroom. The legacy of John Purcell Fitzgerald's generosity remains today as his almshouses are still in use providing comfortable accommodation for Seaford pensioners.

Earlier this year I was lucky enough to be invited into the building as it was again being renovated. Michael Greve, the Chartered Architectural Technologist, showed me around. The roof is reached via a narrow spiral staircase, pierced with medieval style arrow-loop windows. Set into the wall of the staircase is a door. Michael managed to open it and I was surprised to see a huge secret safe, which was obviously used to keep the Fitzgerald Charity funds.

Climbing onto the roof of this Victorian building I was presented by magnificent views across Seaford's rooftops towards the South Downs and the sea. I was surprised to see not just one set of 'Tudor' chimneys but three, all being expertly re-pointed.

The secret safe.

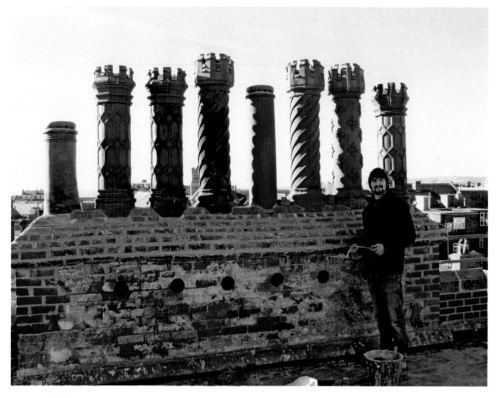

On top of the almshouses.

Four Identical Gordons

We will continue up Croft Lane to East Street. The four terraced houses opposite Croft Lane have a bust of a moustachioed head above the door. I believe that they represent none other than the famous Victorian hero General Charles George Gordon – Gordon of Khartoum.

The basis for my theory is threefold. Firstly, the figures look like General Gordon; secondly the building of the houses would be contemporary with the death of Gordon in 1885; and thirdly the great man actually had a connection with Seaford.

Two of General Gordon's aunts lived in the area; Henrietta Augusta Gwynne (*née* Gordon) lived in Denton, Newhaven, and Anna Maria Wallinger (*née* Gordon) lived with her husband Joseph at Crouch House, just a few yards from East Street. I have been told that, as a child, General Gordon often used to spend his holidays in Seaford, staying with his relatives in Crouch House. I have been in contact with the great-great-great-great grandson of Henrietta Gwynn, who has been able to confirm much of this information.

Gordon was killed by Sudanese rebels who were attacking Khartoum in 1885, two days before a British relief force arrived in the city. His death made him a martyr in the UK and 'Gordon of Khartoum' was commemorated across the word with statues being raised as far apart as Trafalgar Square in London and in Melbourne, Australia. I believe that the people of Seaford also commemorated him in stone, quite modestly, by using his

A stony General Gordon.

portrait to decorate four new houses in the town. A small memorial that, despite being overlooked, remains in the town to this day.

East Street

We will turn right along East Street towards the Crouch. Opposite the end of the High Street is the Seaford Telephone Exchange which holds another secret – sadly not accessible to the public.

The Telephone Exchange was built in 1936. The new King Edward VIII succeeded to the throne in January so his cypher was cut into stone and placed above the main

The rare Edward VIII cypher.

entrance. The troubled king, however, abdicated in December and was never crowned. The Telephone Exchange, therefore, was stuck with something very rare – the cypher of an uncrowned king.

DID YOU KNOW?
Seaford has East Street, South Street and West Street but no North Street. Records show that North Street was the previous name of Place Lane.

Continue along East Street and enter the Peace Garden via the gate on the corner.

In 2011, Seaford Quakers raised money to turn the old Rose Garden into a smart new Peace Garden. The square garden is surrounded by old flint walls and small sculptures with lines of beautifully carved text which add to the serenity. The eye, however, is drawn to the centrepiece of the garden, a soaring sculpture by local artist Christian Funnell. Funnell also designed the interesting gabion-style seats and of course 'The Shoal', mentioned earlier.

The garden was the idea of former local councillor and Quaker Ralph Taylor, who persuaded actress Sheila Hancock to open the garden. Sheila is not only a Quaker but also knows Seaford, having regularly visited the town on holidays when she was young.

Leave the garden via the doorway that leads into the Crouch Gardens and turn left through an archway, where you will find another garden. The Community Garden is a hidden gem; it provides a much-needed growing space for local people who do not have access to a garden.

The volunteers experiment with various methods of growing, even using seaweed, to ensure the best results. There is a classroom where workshops and demonstrations are held and also a pond. The garden is open at various times throughout the year but

Sheila Hancock opening the Peace Garden.

The Seaford Community Garden.

regularly on a Saturday morning in the summer months. It is always worth a visit because there are home-grown plants and vegetables on sale.

Close to the entrance of the Community Garden is an often overlooked plaque to commemorate the gift of dozens of trees following the devastating storm of October 1987. They were a gift of the good citizens of Bonningstedt, our twin town in Germany.

Leave the Crouch Gardens via the corner gate which leads into The Crouch. This area was the site of the regular market and The Crouch is probably named after the market cross which would have once stood here. Hidden in the grass near the entrance of the Constitutional Club is one of the oldest things in Seaford.

It is a Sarcen Stone (also known as a Grey Wether or Saracen Stone) and is around 3,000 million years old. Sarcen or Saracen means 'foreign' and to the ancient people of Seaford who were used to chalk and flint, this large lump of gold coloured rock would have been most mysterious. Where did it come from and how did it get to Seaford? It is obviously far too big to have been washed ashore.

Actually the stone is made from compacted silica-rich sandstone (although some also have a considerable amount of flint mixed with sandstone). This rock once formed a covering over the chalk of the Weald. Over millions of years, and helped by the odd Ice Age, this cap of rock was worn away, leaving small remnants such as the one at Seaford. It was pushed down to Seaford by movements of ice which scoured the top of the Weald away. These stones are properly known as 'glacial erratics'. This was not the last Ice Age, as that did not reach as far as Sussex.

Lumps of this rock would be found on the South Downs, where, from a distance, they were mistaken for sheep (the word 'wether' is an old name for a sheep). As Sarcen stones

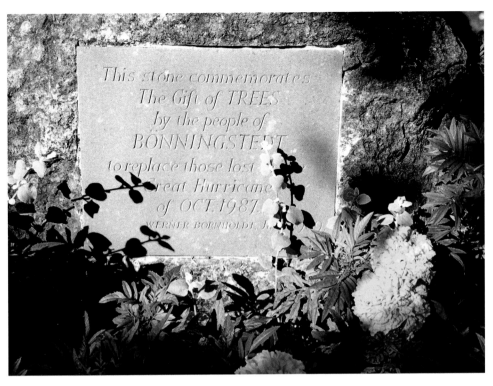

The Bonningstedt plaque in Crouch Gardens.

The ancient Sarcen stone at the Crouch.

are hardwearing they would also be used as boundary or estate markers. Perhaps the largest Sarcen stone in Sussex was at Hove – just opposite where the home ground of Brighton and Hove Albion used to be. It was a large 'gold stone', hence the name of the old stadium.

Follow the crouch around into Crouch Lane and head back towards the High Street. On the left is a gate with a forecourt beyond. The initials on the gates 'BB' give us a clue to the former occupants, the Berry Brothers, who were blacksmiths. A circular metal plate set into the tarmac is another template for making cart wheels.

Opposite is the former blacksmiths of William Funnell, decorated with an anvil and the date 1891.

Turn left into the High Street, once the main shopping street. The Lucky House restaurant on the right was once Robin's Brewery – you can only just make out the name on the side but the name on the doorstep is quite clear. The shop on the corner of Broad Street was the site of the Old Tree Inn, named after the gallows that once stood here in Hangman's Acre.

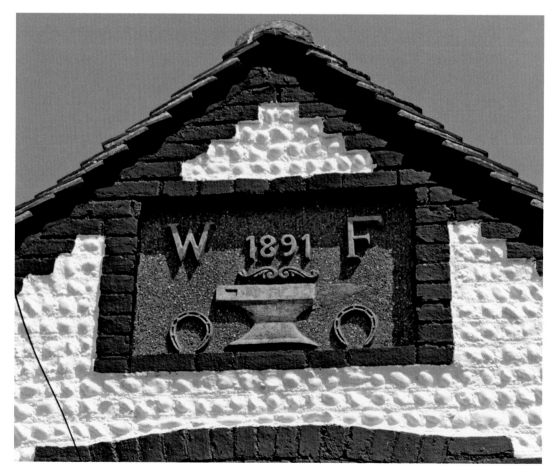

The sign of the Blacksmith.

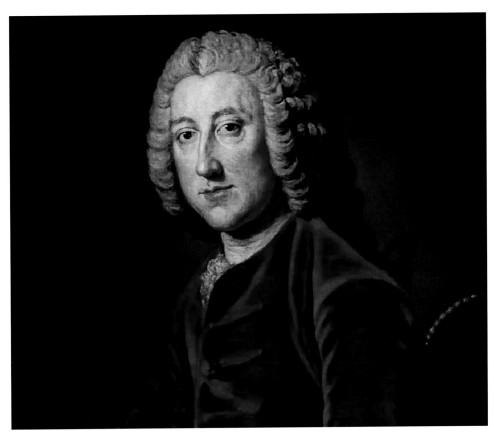

William Pitt the Elder MP.

On the corner of the High Street and Saxon Lane (which was called Dark Lane until a new gas lamp was installed in 1887) stands Pitt House, made from knapped and squared flints, which would have been expensive to make. This was said to be the house used by William Pitt the Elder when he visited Seaford whilst he was the town's MP between 1747 and 1754. Pitt was one of three Seaford MPs who were Prime Ministers, the others being Henry Pelham and George Canning. Pittsburgh in America is named after him as is Pitt Drive and Chatham Place in Seaford. (He was also the Earl of Chatham.) Pitt's son, William Pitt the Younger, also knew Seaford and was a Freeman of the town.

DID YOU KNOW?
Peter White is one of the longest-serving town criers in the country having, started oyez-ing in 1977. He wears an authentic uniform carefully copied from Victorian photographs. Peter is also the Sergeant-at-Mace and carries Seaford's Elizabethan mace at civic ceremonies.

There are two buildings in the High Street faced with 'mathematical tiles': Regency House and 12 High Street. Nearly 200 years ago these two old buildings would have had wooden battens fixed to the façade and from these layers of mathematical tiles would have been fixed, held in place with nails. The tiles were designed to look like bricks.

A mathematical tile.

The course of tiles would have started at the bottom with the next course covering the top of the tiles, hiding the nails. Sometimes lime putty would have been used to 'glue' the tiles, making them even more secure. Often the gaps between them would have been filled with mortar, making them virtually indistinguishable from real bricks. I am sure that you have passed these two buildings in the High Street on many occasions but had not realised their secret construction.

On the right-hand side of the road is 'The Old House', reputedly used to hide contraband. Closer inspection will reveal that two old cast-iron firebacks, one dated 1625 and another 1755, have been set into the front of the building. These would have once been set into the back of a fireplace to protect the brickwork and are a remarkable survival of domestic heritage.

The Old House,
High Street.

Above: An ancient cast-iron fireback.

Left: A crown window at the Crown Pub.

Turn right into South Street and head up towards the church. The tearoom on the left was once the Town Hall and the scene of the regular elections mentioned previously. The first floor was the council chamber but the cellars contained prison cells, once described as 'The Black Hole of Seaford'.

Before we finish our tour don't forget to visit the Crypt Art Gallery nearby. It is not only an excellent centre for the arts but also contains a beautiful medieval vaulted undercroft. This dates from the latter part of the thirteenth century and would have been used by a wealthy wool merchant; the vine leaves on the bosses of the vaulting also show that he was importing wine from France.

Talking of wine, it's time for a drink! The Crown Inn near the Crypt has been a popular pub since the 1870s and is decorated with some fine Victorian etched glass. The nearby Plough has been a pub for much longer and is decorated with some old views of the town.

Secret Tunnels

I have been interested in the history of Seaford for nearly thirty years and one subject regularly comes up – the secret tunnels.

I have done my best to find physical evidence of tunnels. I have visited old houses and ancient pubs, and been down many a cellar. I have seen coal chutes, alcoves, wells, drains and pits, but nothing remotely resembling a tunnel used by ancient Seaford smugglers. Any tunnel under Seaford would be below sea level and regularly flooded.

Several Seafordians have told me that they were told about the tunnels when young, but no one is able to actually show me one. Throughout this book I have tried to reveal some little-known facts about Seaford, however, maybe the best kept secrets are the town's tunnels that are still waiting to be discovered!

Acknowledgements and Bibliography

I would like to thank Seaford Museum, the National Archives, Rottingdean Museum, Mandy Gordon, David Swaysland, Philip Pople, Rosemary Collict, Ben Franks, Diana Crook, Peter White, and members of the History Club for their support and the use of photographs.

Longstaff-Tyrell, Peter, *Operation Cuckmere Haven* (1997).
Lawson, Lyn, *The House on the Hill* (2016).
Creedon, Conal, *The Immortal Dead of Michael O'Leary* (2015).
Castleden, Rodney, and Murray, Ann, *All is Hush'd* (2016).

About the Author

Local historian and author Kevin Gordon provides regular guided tours of Seaford, Lewes, Alfriston and the nearby Tide Mills. Details of his tours can be obtained from local Tourist Information Centres or at the website www.sussexhistory.net